Black
Interest

NEW LONDONERS

REFLECTIONS ON HOME

* * T R O L L E Y * *

FOREWORD

New Londoners is a collection of photographs and writing by fifteen young people, aged thirteen to twenty-three, who have been mentored by a selection of London's most established and emerging photographers. Coming from nine different countries, with diverse experiences and backgrounds, they all share one common experience : they are young refugees separated from their families and homes, who are rebuilding their lives in London. This book is the result of a collaboration between PhotoVoice, an international charity which provides photographic training to marginalised communities, and Dost, which supports vulnerable children, including young refugees, through education, play, advice and advocacy.

Through images and words, we understand something more of London itself, and of their lives as young people finding their place in a new city, far away from home. Reflecting on their experiences of home, as both the place they have left behind and the place where they have arrived, the photographs are also about transition – from one place to another, from dependence to independence, and from one way of life to another.

This book asks its readers to actively listen to these young voices. To reflect on the way that they see the world. To recognise their place in London. To acknowledge all that we have to gain from exploring different ways of seeing.

We are very grateful to all the mentors for their time, support, patience, commitment, and ideas.

We would also like to thank the young photographers, for their hard work and commitment to photography, and for sharing their views so honestly. The creative ideas in this book belong firmly to them – new young photographers who have so elegantly and confidently made the camera do what it does best : tell stories, create memorable images and record important histories.

Tiffany Fairey and Liz Orton
PhotoVoice
Yesim Deveci
Dost

INTRODUCTIONS

Photography is, as is often remarked, a way of stopping time.
We experience reality as a relentless continuum, just one
damn thing after another, but the photographer has the power
to extract moments from this flow and hold them up for
our examination. In this way, photographs make the familiar
unfamiliar, which, in a city as large and hectic as London, is
a useful tool. City people habitually forget to look. Much
escapes our attention. We're too busy jostling one another
in the bus queue, cramming ready meals into our shopping
baskets, trying to attract the attention of the taxi driver or the
nightclub barman.
For those of us who've lived in London all our lives, it's
interesting, and often very moving, to see the city through the
eyes of its newest residents. The struggle to carve out a life in
a global metropolis is, in a way, much like taking a picture. You
reach into the churning flow and try to extract something, one
thing, which has a shape and a purpose, something which will
belong only to you. In the hands of young refugees, the camera
becomes a tool, not just for defamiliarising one of the most
photographed places on earth, but for making the unfamiliar
familiar, for picking out the friendly faces, the weird food in the
cupboards, fixing the textures of the park and the pavement and
the street market. Taking pictures is a way of establishing that a
new life does have a form, for confronting the looming shadows
and celebrating what's beautiful. Each of the photographs in
this book is a record of a moment of choice, made by someone
who has not always been able to choose the most basic things
about how or where to live. They are also evidence, proof that
the photographer was in a certain place at a certain time, which
is another way of saying that these pictures are memories – and
when you have memories of a place, you're beginning to put
down roots.

Hari Kunzru
Writer

INTRODUCTIONS

As part of the umbrella of initiatives that PhotoVoice has spearheaded since the late 1990s, New Londoners demonstrates how photography continues to be an empowering act for its makers. It activates a shift in the balance of contemporary documentary photography away from the professional photographer with a social conscience visualising the challenges of others, towards the observations that only we can make upon our own lives, no matter how marginalised. In an era where the meaning and motivations for professional documentary photography have undergone considerable changes, an important space has opened up for personal photographic explorations that communicate social and political realities.

The world has created a vast architecture of image downloading, websites and blogs to both receive and offer an audience for every photographic observation we could possibly make. Our documentation of our own lives has been galvanised by new collectively controlled public arenas on the web.

As a collection of documentary 'voices', the photographers that constitute New Londoners create a symphony of observations and experiences of London. Making photographs – visualising and interpreting the world around you – is an emphatically empowering act. It is through photography that these recent arrivals in the city further understand and command the situations that they face.

Some of the projects here make inherently personal uses of photography to document the day-to-day meeting of familiar routines with a new culture; what you eat, where you are housed, what now surrounds you. The New Londoners show us the poverty and harsh urban reality that they had not imagined of this sceptred isle, made all the more real by the casual, photographically direct way in which such observations take their form. There is a brilliant conflation of cultures and aspirations meeting the reality of contemporary London, played out in realistic and inconspicuous forms of photography. Some explore the symbolism of the city through photography – seeking and finding the emblems of a foreign reality as well as signs of emotions and environments that trigger memories of homelands. There is a romanticism, sometimes realised with colour and abstraction in some of the work, where an emergent photographer finds emotional expression in the medium. In the hands of these New Londoners, photography is a powerful tool for scrutinising and feeling themselves to be in a new place. One of the strong undercurrents of New Londoners is the experience of the city's multiculturalism. They use photography to explore how being in London is not simply a question of how one's own culture interacts with a dominant and native identity but is a much more complicated plurality. The New Londoners investigate multiculturalism in many ways; by adopting and performing a range of identities observed in the city, using Photoshop to situate each character in their most likely environment. Or using a real talent for photographic strategy, another photographer makes portraits of the range of people who come from around the world and have been able to become UK citizens. She captures the new British before, after and while waiting for their citizenship ceremony, and her photography becomes part of the ceremony of these symbolic moments. The networks that support young refugees are important within the narrative of New Londoners. The communities and people that create a meeting point, a warm welcome and practical help for individuals who are new to London are celebrated in this book. Through them, the photographers construct a very real and life-affirming story of the city. There are beautiful portraits of people who activate real support and social change for others. In a direct way, photography gives these makers a reason to celebrate and analyse the relationships that deeply and positively affect their experiences in the UK. That same celebration of human kindness and bonds comes across in the portraits of friends in this project.

Photography has the capacity to shape and enrich our experiences and PhotoVoice constructs ways for this power to be profound – both for the New Londoners and the readers of this book.

Charlotte Cotton
Head of Department and Curator of Photographs,
Los Angeles County Museum of Art.

"First impressions count." That's how the old adage goes. This collection of photographs and comments amounts to the early impressions our capital city has made on some of its residents. But these New Londoners are no ordinary residents – they are here in search of asylum. They are living contradictions – brave enough to make the often dangerous journey to our shores and yet vulnerable enough to wonder if they will ever be accepted. You see this inner struggle in so many of the captions that accompany the sometimes telling, sometimes light-hearted pictures in this book. Chalak, a Kurdish refugee from Kirkuk in northern Iraq, describes this tension with all the simplicity of a poet: "Wanting to be here, but missing there," he says.

I've written elsewhere, in 'A Home from Home', that the toughest frontier to cross is the one that lies between two questions: "Should I go?" and "Shall I stay?" For many of these young refugees - coming from war-torn corners of the world - there was no choice; that agonising decision had to be made by parents or families hoping that Britain would offer a future that their country couldn't. The contributors in this book are struggling through that challenge – some with great flare, some more hesitantly, but all of them determined to fulfil the promise of a better life in a strange land.

Migration is like a mountain that separates the past from the future. There is much to learn in their journey because strangers' eyes see things about us and our country that we no longer notice.

What a pity, therefore, that so many of these journeys – each one of them different, each one of them epic – are so often reduced to sensationalist headlines. Here we see beyond those headlines : a different picture comes into view.

Every country has a right to decide who and how many people it is willing to accept, but in Britain the much needed public discussion about asylum has been contaminated by fear – much of it whipped up and unwarranted. This book shows us a group of talented and sensitive young people who say they want nothing more than to contribute to our society.

Disquiet, even anger, about perceived misuses of the asylum system have meant that support for helping refugees – something for which there are many historic precedents in this country – has withered. It's hardly surprising that in May 2008 the Independent Asylum Commission said the word 'asylum' should be replaced by 'sanctuary'.

So it seems asylum has become a dirty word – and what a shame. It is a noble and ancient tradition with roots deep in Britain's gradual, sometimes bloody, transition to a rules-based society. On the great North Door of the Norman Cathedral in Durham, where I went to university, is a bronze knocker. Throughout the Middle Ages Durham Cathedral was a place of sanctuary. Any fugitive from the law could claim protection by knocking on that door. The story of that knocker is an eloquent reminder that the notion of refuge, of giving someone a safe place to stay, is much, much older than the modern argument about asylum.

Today's asylum seekers leave behind virtually everything they own except a yearning for justice and a hunger to work their way into a better life. Which nation can afford to turn such people away?

Despite the antipathy showed towards them, refugees continue to see in Britain a beacon of hope. Some of the young people in this book reflect on the support and care they have been shown by others in the UK, the kind individuals who have taken time and commitment to welcome them to this country. The vast majority of asylum seekers come to Britain because of our reputation for tolerance and fair play. They see in us something we have forgotten about ourselves.

George Alagiah
Journalist and Broadcaster

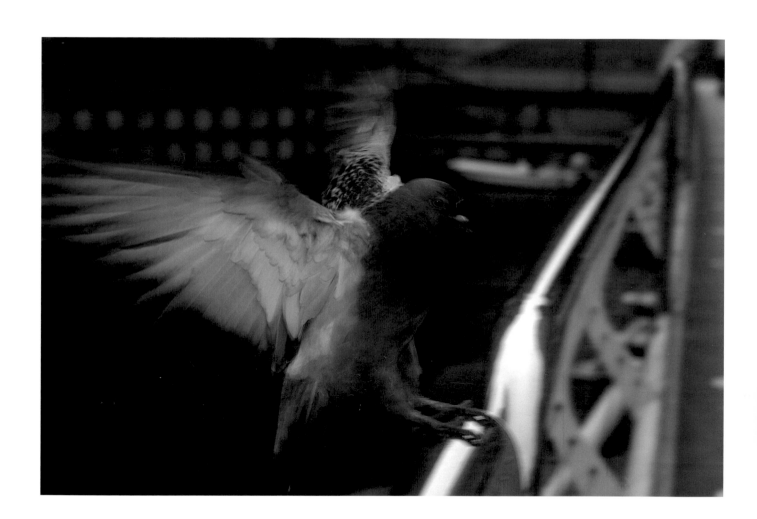

Canary Wharf

WAITING FOR AMY BY BAJRAM SPAHIA

FIRST CAME TO LONDON: 2001
PHOTOGRAPHIC MENTORS: ADAM BROOMBERG AND OLIVER CHANARIN

I came to the UK in 2001. My first impressions of London were strange. I was in East Ham and it was not like the London I had seen on the television. I lived with a foster family. They were Indian and I had never seen people eating with their hands before. The experience of seeing different customs and lifestyles was new. After a while, I got to know about these cultures and I came to respect them. Once you get over the strangeness of the difference you understand how many things are the same.

After being here for seven years I have been converted to the life here. I came to London as a kid and now I am an adult. I have changed in many ways. I feel British. After a long time waiting, I now have a UK passport. It's important because it means I am like everyone else. And now I can go home and visit my parents and see the country I have missed so much. I can't wait to go but I will also look forward to coming back. London now feels like home.

One of my friends was working with the paparazzi and he told me they were looking for a videographer. It sounded fun, filming celebrities, and I needed money. London is not an easy place to make a living. You have to do things to survive, to pay your bills. Life in England is stressful, you work hard.

I enjoyed it for the first few months, it was exciting. I learnt about London; went to the posh parts of town. I learnt about film actors, who they all were and I saw them in real life. I enjoyed doing the film premieres and parties.

As the days passed, it became a job. People don't want to be filmed and it doesn't feel good. I realised it was something I didn't want to do. I found out that paparazzi don't have a good name. I think if you work as a pap for too long it changes you. When I started I didn't understand about celebrity culture in England. Kate Moss walks from her house to her car, and in the newspaper the next day the picture is shown with a totally different story. People are crazy about celebrities. I have no idea why. I am not interested in these celebrities' personal lives. It does not feel right for me to follow them.

These photographs have been taken over a few months while I have been waiting. I have waited in so many places : on the Kings Road for Kate Middleton, outside Madonna's gym, outside The Ivy for whoever comes, outside Amy Winehouse's home, in a field in Wales for Charlotte Church, outside court for Pete Doherty. If I see something, and it says something to me, I take a picture. They are quiet moments. They are not so much about London but about what I see in the city – animals, places, things that caught my eye or reminded me of home. I have stopped working in that job now. I realised it wasn't something I wanted to do. I need to do something I am proud of and that people will appreciate.

Waiting for Charlotte, Wales

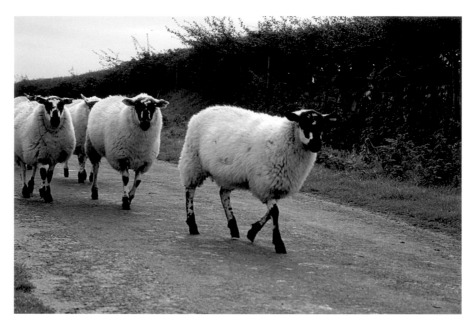

Waiting for Kate, Chelsea

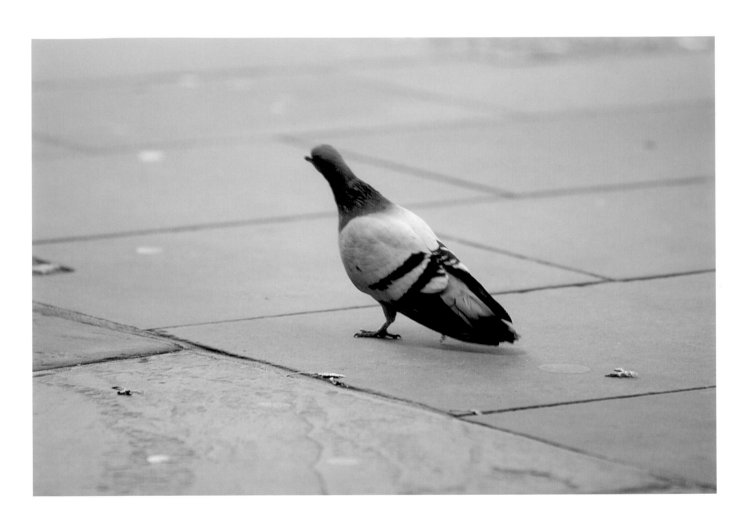

Waiting for Amy,
Camden

Waiting for Heather, Regent's Park

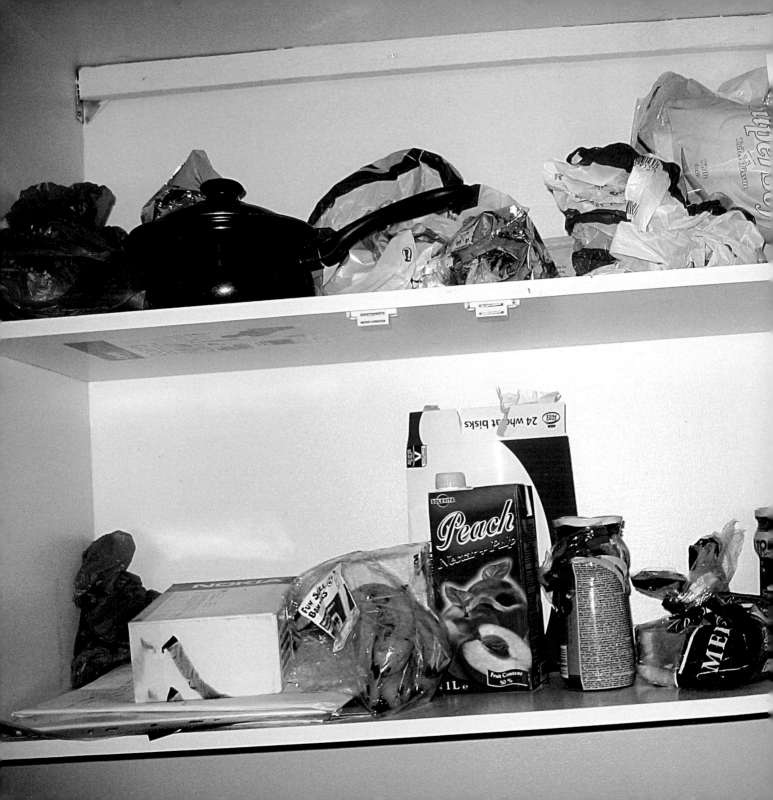

THEY SEEM TO BE OURS BUT THEY ARE NOT...
BY MUSSIE HAILE
FIRST CAME TO LONDON: DEC 2006
PHOTOGRAPHIC MENTOR: CRISPIN HUGHES

I feel this picture is interesting because it shows
how I am living independently.

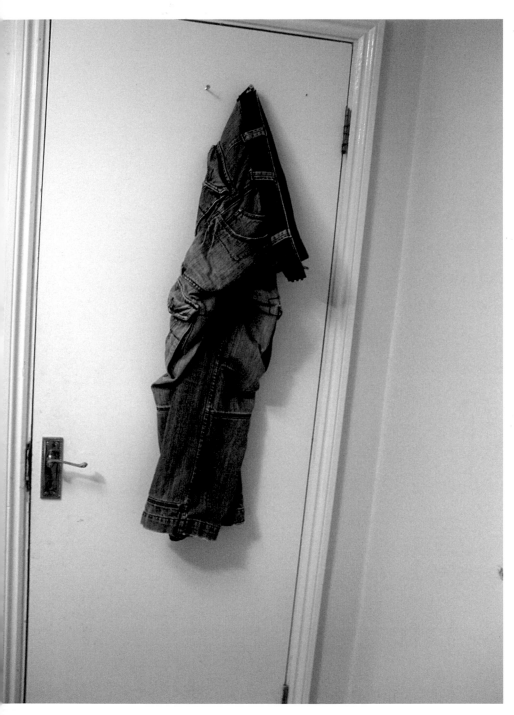

Left I like the pockets in these trousers. I can't find good quality, fashionable clothes in London. They are better in Eritrea.

Right This picture is interesting and makes me wonder. It was the first time I came into contact with the police in England. I was stopped and searched when I was waiting for Crispin outside Downing Street. Afterwards I took this self-portrait holding the piece of paper they gave me.

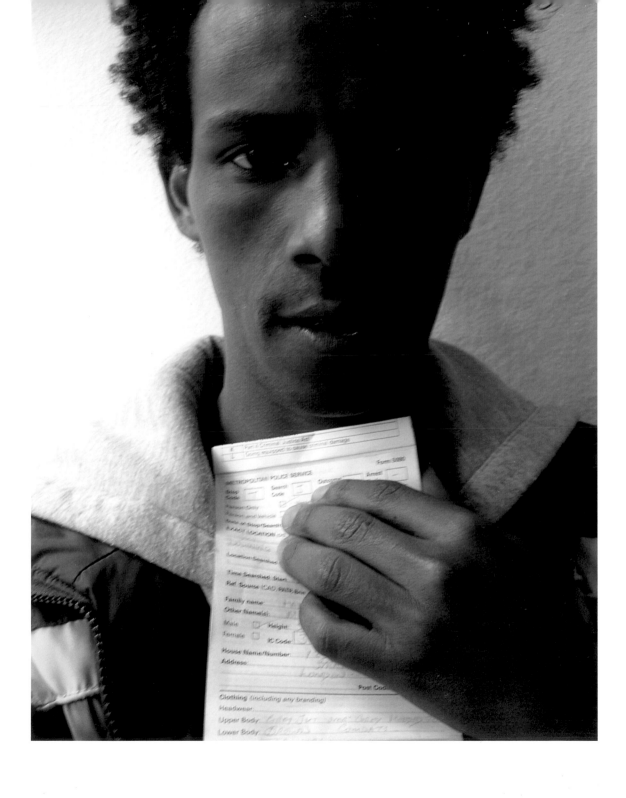

Top This picture shows a mixture of pasta. I mixed them up because one packet ran out.

Bottom At home we make injera and bread as well, by grinding grain to flour. We make dough and cook it on a flat aluminium sheet with fire underneath. We burn wood usually, though you can make your own charcoal. When I was very young we had sheep and goats to make yoghurt but they all perished in the drought.

Top I saw this for the first time in England. I had never seen it before. Now I know it externally but not yet in detail.

Bottom I am re-heating rice in a closed plastic box. In Eritrea it would be completely and absolutely rude for a woman to sit while a man cooks. A man goes out to plough the field and does outside work. If he drinks and hits his wife it is normal. Here the culture is completely different.

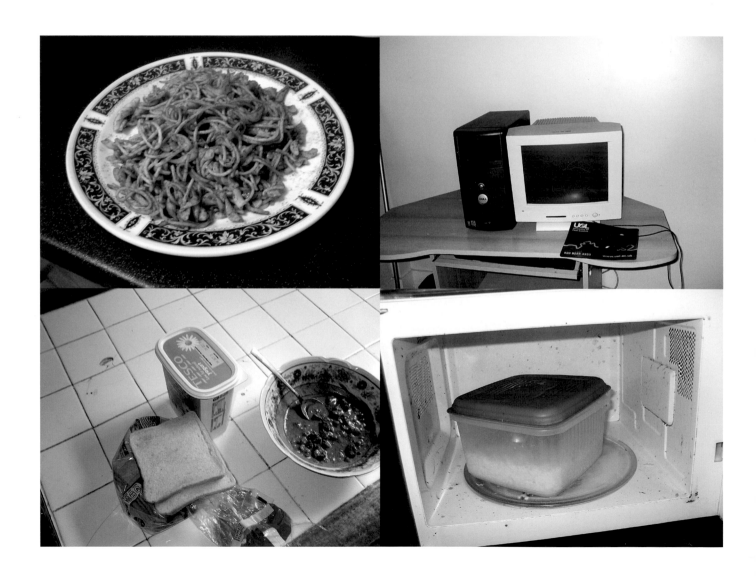

Top I feel this is an interesting picture because I don't know how to cook pasta. I like it, but I don't know how to cook it. In Eritrea we would cook traditional food.

Bottom I really like this picture because of the writing which says Credit Expert. I need money and I need to know how to get it. These people know about money.

Top I haven't seen this before. A bulb with protection. When I was in my country, there was no electricity in the countryside where I lived. Even in Asmara I never saw a bulb with protection like this.

Bottom Everything is available here. I lived in the countryside and you would have to pay money to someone in the city if you wanted something ironed, perhaps for a wedding.

Top To wash, we went to the lake. The mothers, though, might wash at home with water brought by them or the children from the lake.

Bottom In Eritrea we got water from the lake 3 to 5 kilometres away by donkey. My family had three donkeys. Collecting water was definitely a woman's job. For washing clothes we would take them to the lake, use Omo and then dry them on the stones.

I am young and careless, so I don't make
the bed nicely.

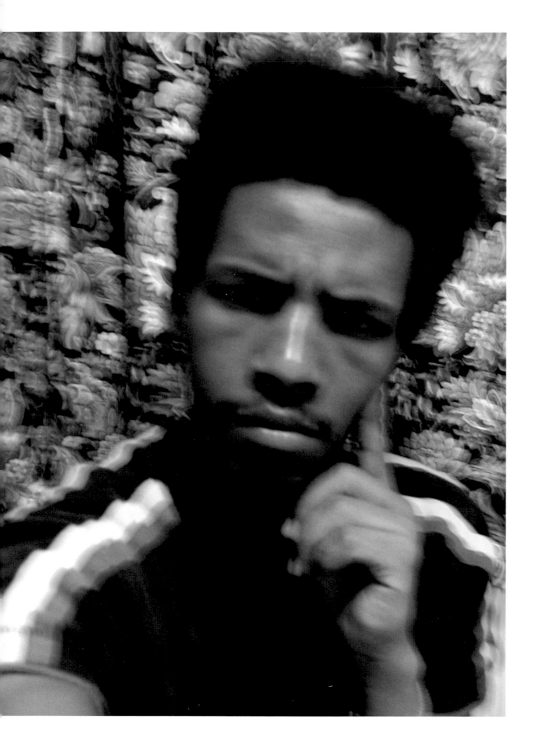

I am interested in this picture because it is a self-portrait. I chose a gesture in the picture which shows I am thinking deeply about the future.

This picture is of an apple tree. It is not our garden but it comes down over our garden. That's why I wanted to take the picture. When I look at the apples they seem to be ours, but they're not.

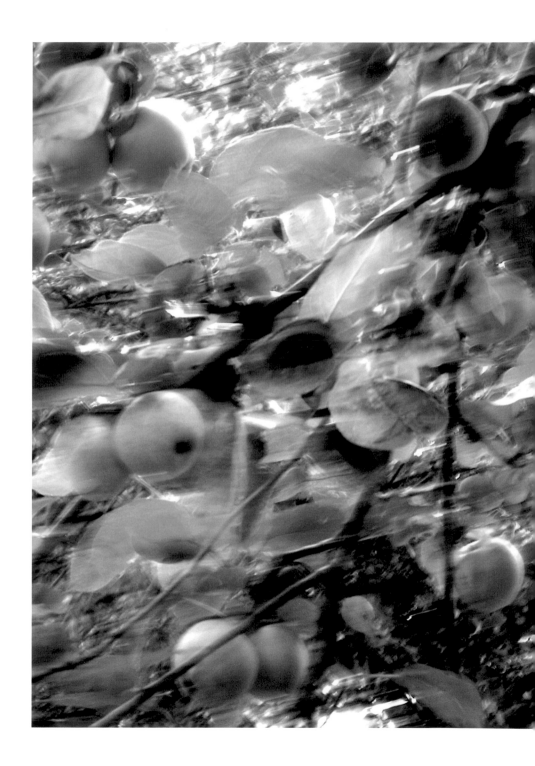

I live in Streatham Hill with my foster carer, who has been a caring person. I really love the house where I live and the environment. The area is really quiet compared to where I come from. Looking at this house where I live it is so big and nice. In my country it would be only for rich people or white people. It is amazing for me, a 'wow' for me.

My room is big and beautiful and painted in white. I have a big bed. In my country I didn't have this opportunity, I did not know the meaning of having a big bed because me and my sisters used to sleep five in a bed, sometimes even on the floor.

I AM NOT ALONE BY LORIA SIAMIA
FIRST CAME TO LONDON: DEC 2005
PHOTOGRAPHIC MENTOR: LIANE HARRIS

At first I didn't have any idea of how London would be. I didn't actually know that I was going to be coming to this country. The image that we have in the Democratic Republic of Congo of Europe is peace, nice food, and a different sky. So coming here was something really new to me; the weather, friends, food, culture, language and behaviour. It took me time to fit in because of my lack of English.

I think London is a great place to be, you don't have to worry about your life. There is a law that people have to follow and there is democracy, London is beautiful, people are generally nice, there is a lot of affordable food, my bus pass is free, and school is free. You can get support and people are always willing to help. It is just like a paradise. London for me is like being blessed by God because so many opportunities that I have had here, others do not have.

In the Congo, things like ice-skating, going to museums or restaurants are only for people with money. My parents couldn't provide these opportunities, so for me, seeing how people do all these things in London was amazing. We do not have cinema in my country because we do not have the equipment, and also because there was never electricity it was impossible to watch TV.

But life in London is also really hard. I don't like the weather, it is too cold. Sometimes I miss my country because of the weather. Here I have to be responsible for everything; my money, going to the doctor... you have to fly for yourself at such a young age when you haven't been trained about so many things. Sometimes you can be really lonely, frightened and worried. I fled my country because of lack of security but I think you are not safe anywhere. Sometimes when I am walking home I feel afraid that something is going to happen to me, as teenagers in London are being killed.

People in London can be so closed, and when you take the bus, train, or the Underground everyone reads the newspaper, and it is hard to see anyone who is going to smile at you that day or talk to you. I am sad when I think of my family and when I hear or see on the news people who are suffering. I don't like to see people mistreated, I hate injustice.

My friends are always there to make me laugh when I am sad, and smile when everything is going badly. In my career I want to help those who have been through hard times to overcome their fear and to be strong because life is a learning journey. You learn each time and your experiences make you stronger.

I really enjoyed taking these photos. Through photography I have looked at things more deeply, like looking into my life, and seeing how to move on. Choosing the photos that go together is like chemistry. You mix chemicals together to find the different elements that give a result. Something about them makes me think of how music links people's lives, the way these photos link with mine. Photography has been a therapy for me, I learnt how to break free of myself.

The entrance to where my social worker works
is like an emotional doorway to getting help
with your problems, where problems get
solved. That is the reason why people walk
through that door.

I felt so relieved when I started going to the Refugee Council. They listened to me, and they are always there for me, they cheer me up whenever I do something, they send me nice beautiful cards to say thanks, and help me to participate in different projects to improve my skills. When you come to this country you feel so lost, but at the Refugee Council I met other Congolese people and this reminded me that I am not alone. They also put me in touch with the church.

The church is so special to me. It is a refuge. It is a French/Lingala church. There are lots of things that make me happy. The most important ones are God, my family, friends, my teacher and people who participate in my success. When I am worried and I ask God why, I know he hears me so I feel happy. My family – even though I don't know where they all are – are the most important people in my life. I will always remember them. It is because of them that I am who I am now.

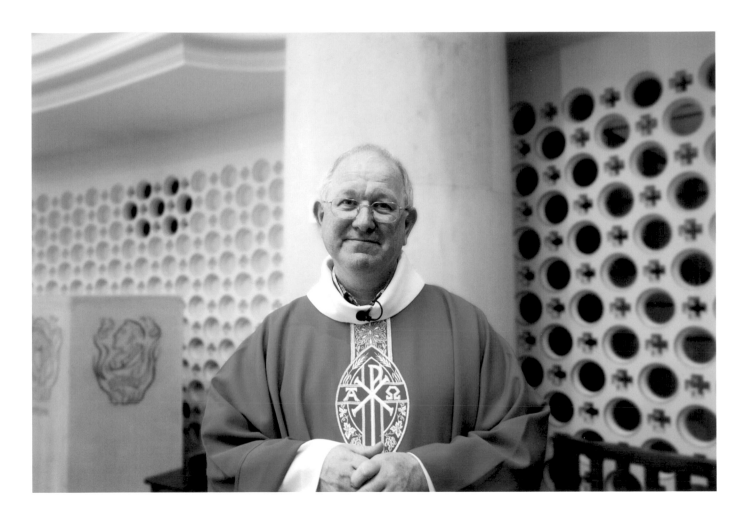

The pictures of my priest and my church are
my favourites.

Alem Children's Section, Refugee Council
When I look at these people, I see comfort,
these people encourage me – this is comforting
and supportive.

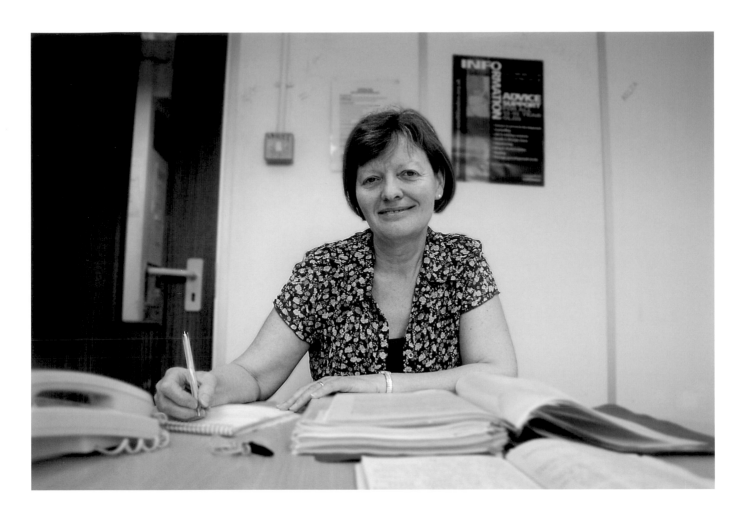

Lesley My social worker is one of the most wonderful people I have ever met. She makes me believe in myself, she gave me hope when I didn't have any. I have become closer to my social worker since taking her portrait.

Caroline Children's Section, Refugee Council
Katie Zoom-In, photography school
Aida Children's Section, Refugee Council
Jennifer Children's Section, Refugee Council

Maybe I'll be happy here. I have not chosen to be here, and have no choice if they want to send me back. I should be happy, but I'm not. I am not able to start my life yet. Not until I get my visa. I am here but I am always thinking about my city, Kirkuk. I want to live in my city, but can't. My thoughts are like this all the time, I want to be here, but I don't know if they will let me stay. I want to be there, but can't be there either. So what can I do? I like London because there are many different types of people from all over the world living together. Everyone is equal but different. In my country everyone is the same, we are all Muslim, but we are all fighting. I love my city. But I want to live in London and be equal, when I get the visa. The photos I have taken were put together to show how my thoughts are. Always in twos, for every happy thought, an unhappy thought. For every time I think of being here, I think of there. Wanting to be here, but missing there. Not being a part of here, but also beginning to be.

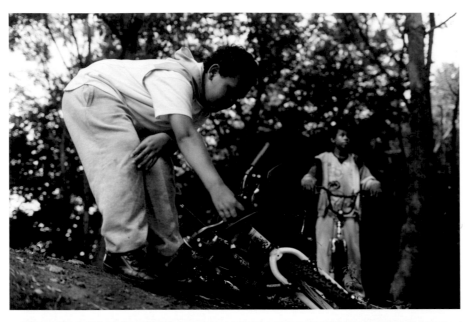

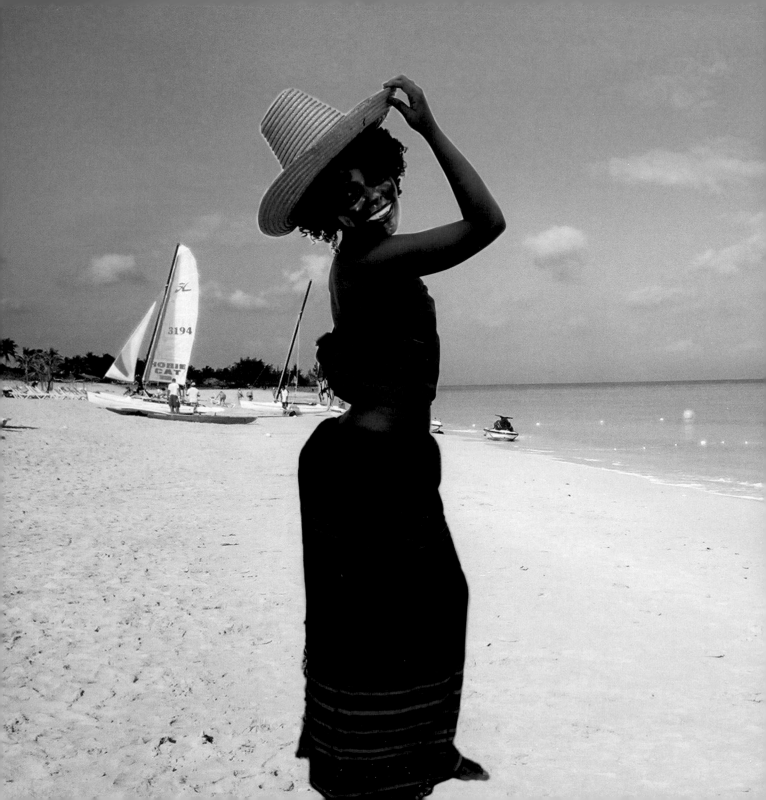

SIDE BY SIDE
BY SHAMIN NAKALEMBE
FIRST CAME TO LONDON: DEC 2003
PHOTOGRAPHIC MENTOR: MARYSA DOWLING

When I first came to England it surprised me when I saw how many different cultures there were all living here side-by-side. Other countries don't have so many different cultures. I love it. When I started doing photography I had a lot of ideas about the many new things I saw around me. I decided I wanted to somehow photograph these different traditions and cultures as I see them. I didn't just want to photograph other people, so I decided I would do it myself. I like performing and dressing up, so I imagined what different people in the UK might do, and how they might look. It's a new experience for me, I've never done anything like this before. I feel great when I look at the photos of myself.

Naomi Taheisha is a Jamaican dreamer. She was born in London and is imagining she is on the beach in Jamaica. She has only seen pictures of it on the internet, in magazines and on the TV.

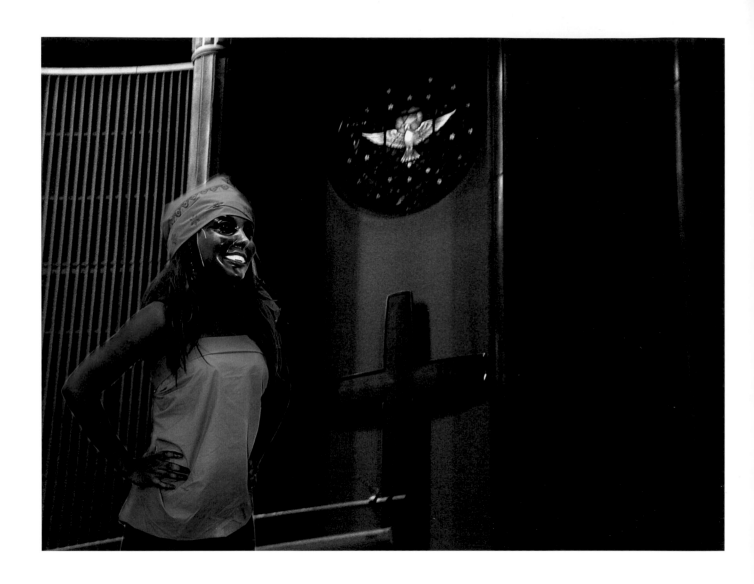

Sherina Katoke a friend of mine from Nigeria, had
her picture taken in the church where she spends
most of her time when she's not at college.

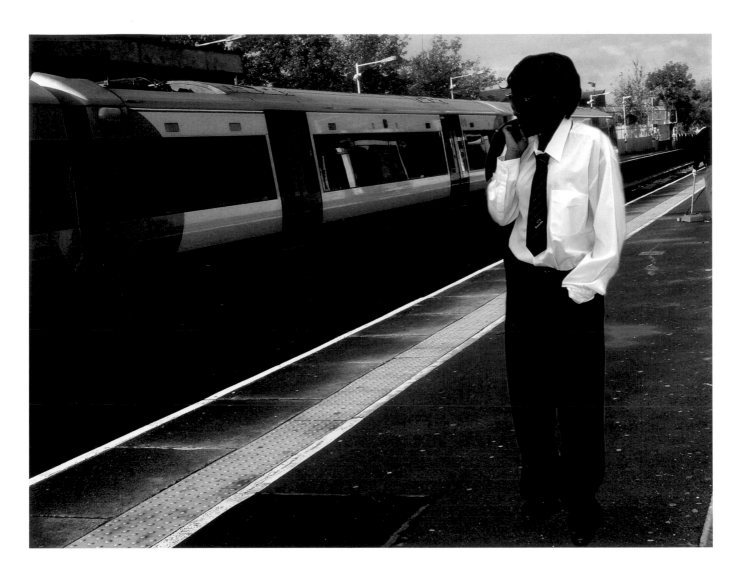

Daniel Belfry waits for his usual 8.45am train
to Victoria station.

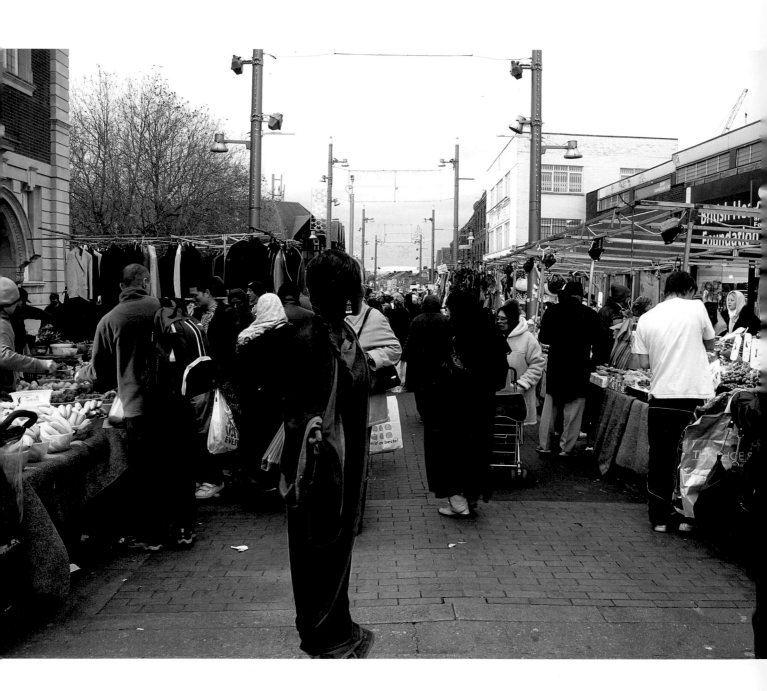

Vaidehi Sita (left) does her weekly shop in Walthamstow market.

Janet Macintosh (right) has just moved down from Scotland. She enjoys a summer day out on a boat on the River Thames. She wants this photograph to send to her family in Scotland.

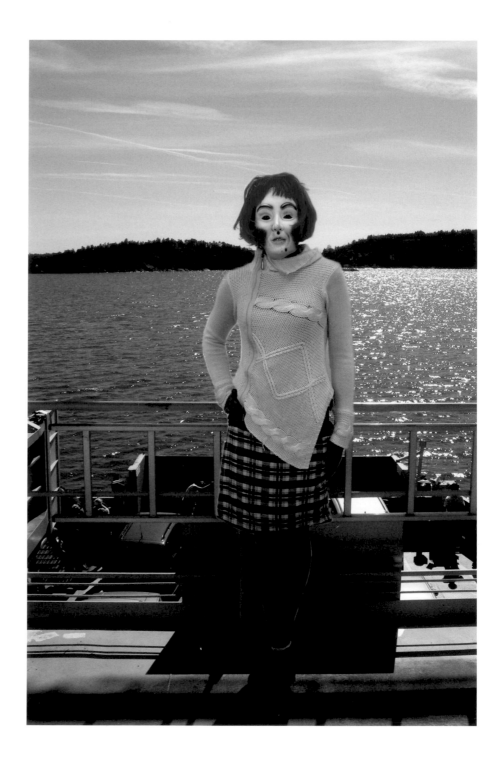

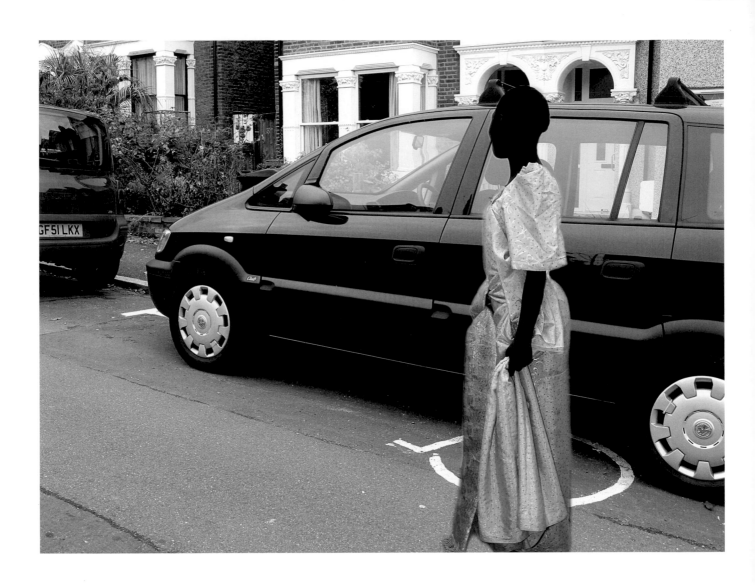

Shiba Nakigozi is on her way to a
traditional Ugandan wedding.

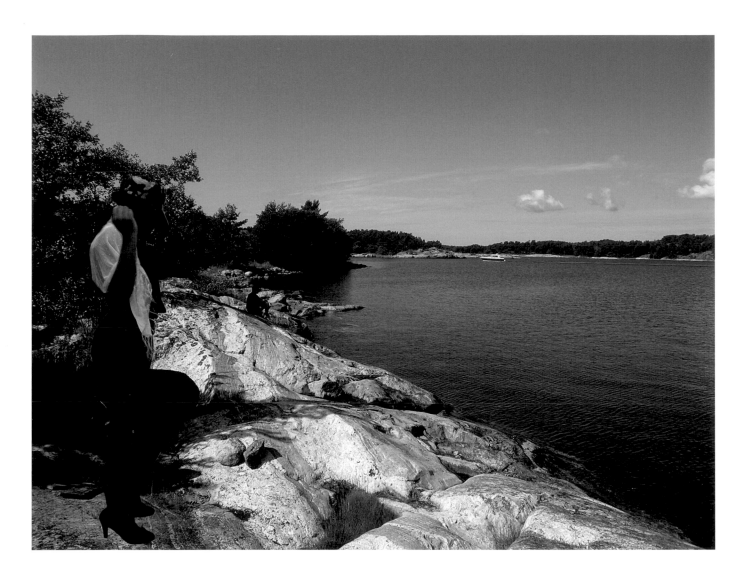

Ace is a fashion icon from the UK. She is promoting her new book in Italy. Here she is, seen at her favourite holiday island in Italy wearing the latest fashion. But would you imagine wearing this in such a place?

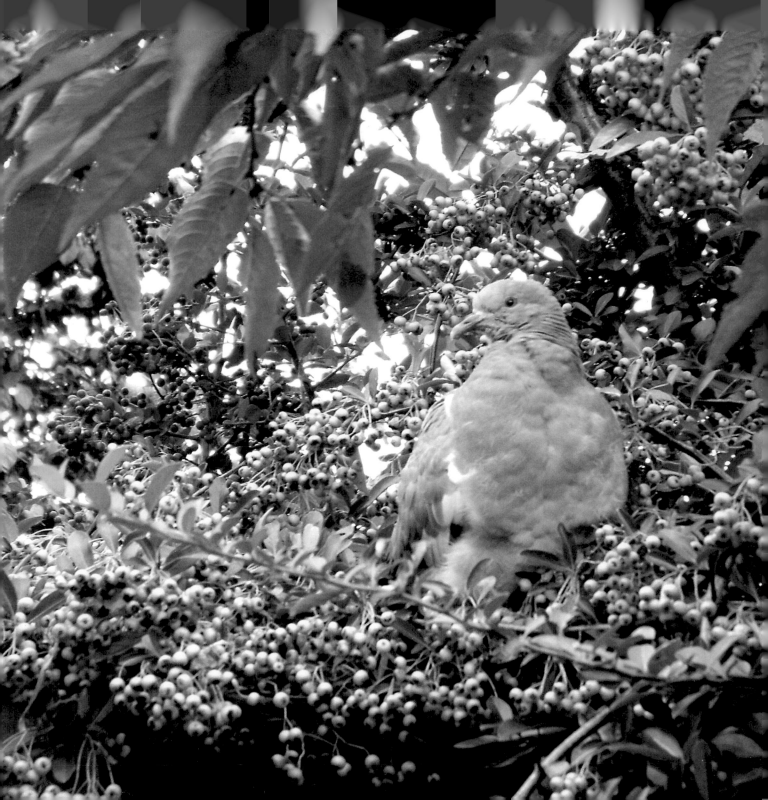

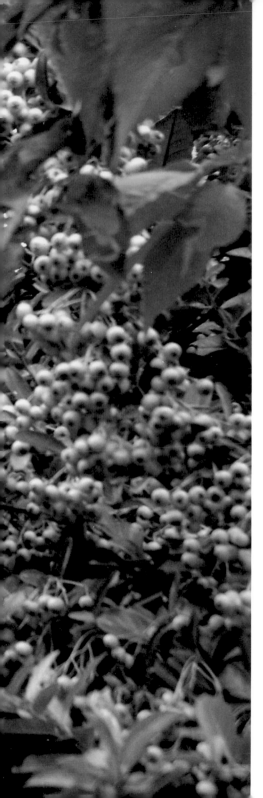

AN UNEXPECTED LONDON
BY AL-MOUSAOY
FIRST CAME TO LONDON: DEC 2006
PHOTOGRAPHIC MENTOR: SUKI DHANDA

The way the bird's head is turned to one side
and his chest is pulled out, he looks powerful
and strong, like a leader....a king sitting on his
throne. He is surrounded by colourful berries,
they remind me of the people in his kingdom. I
think he is looking for his queen.

My friend had no electricity for three days because the landlord did not pay the bill. Every day I took the battery from his mobile to charge it back at my house. This reminded me of Iraq where each day we only had one hour of electricity; people who had their own generators could have power all day, but this also cost lots of money to pay for the petrol.

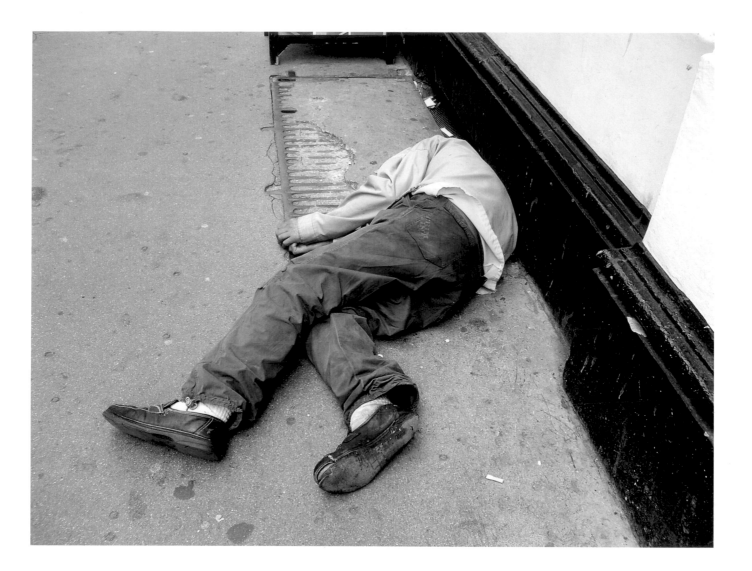

It was a busy road near the British Museum, the man was fast asleep, his clothes were dirty, there were people passing him by and nobody was asking if he was ok. In poor countries we are used to seeing people sleeping in the street but I didn't expect to see it in England. When I saw movies of London back in Iraq it would only show the good things – the buildings, the wealth, the people...not the rubbish and the homelessness.

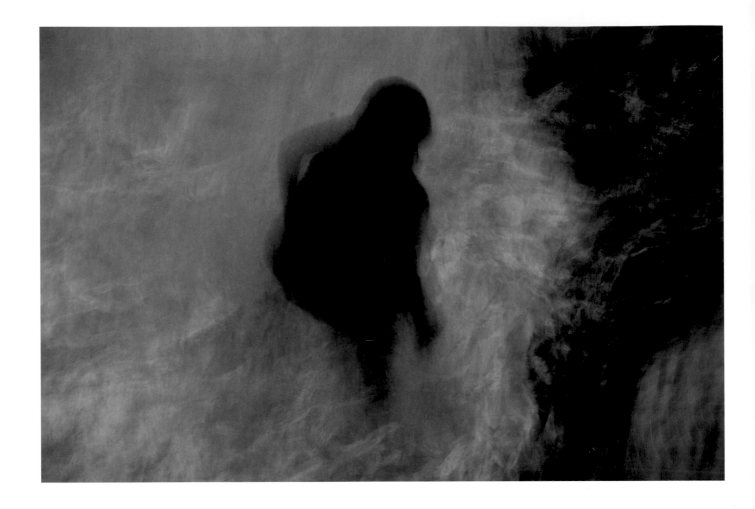

I would love to be able to paint pictures but I don't have the skill. Finally I have found a way to paint with the camera. The girl is walking into the pool from the shallow end, you can't see her legs clearly as she is moving with the water.

The picture is blurred, it reminds me of the thick brush strokes I have seen in paintings.

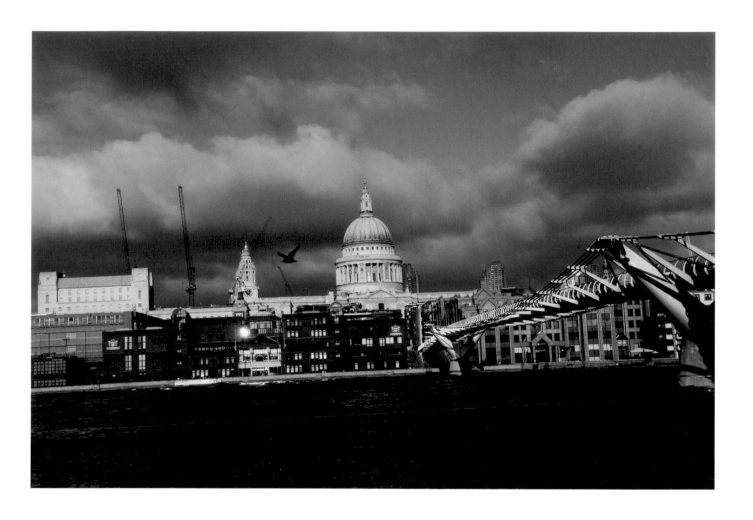

I feel so happy when I look at this picture,
everything fits together perfectly – the river,
the bridge, the blue sky, the way the sun lights
up St Paul's in the background. I would love to
be like the bird flying freely.

In London you cannot tell where most people are from, there are so many people from different countries, who have different nationalities and religions. Sometimes this makes me feel good, more accepted, that there is not just one type of people here – all white.

This photo was taken at a friend's house –
he lives in rented accommodation. I was
shocked at the state of the toilet, the corners
were covered with cobwebs, it was dirty and
needed repair work. It reminded me of a horror film.

People here still ask me why I have come. They tell me, 'Go back to your country.' When the Home Office asks me 'Why have you come to our country?' I will answer 'Why did you go to my country?' I would like to go back to Iraq, my country, with a camera. I want to show people what it is really like. People are dying every day in Iraq. Some are beheaded, some are injured. If someone gets caught in an explosion, and he loses his arm, there is nothing I, or anybody else, can do for him.

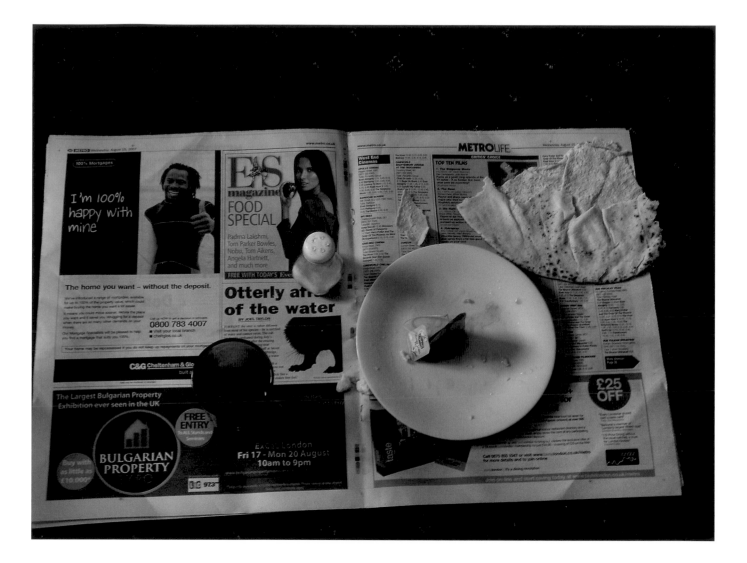

This is my breakfast. I made two eggs, some bread, tea. Then I thought I could take a picture of it. For someone here, it is just my breakfast. But if I showed someone in Iraq this picture, they wouldn't believe it. When we were in Iraq, we imagined England was just like what we saw on TV, in films. Breakfast tables had bread and orange juice. But my breakfast is the same as in Iraq. The only difference is the tea bag. We don't make tea with tea bags, we let tea brew.

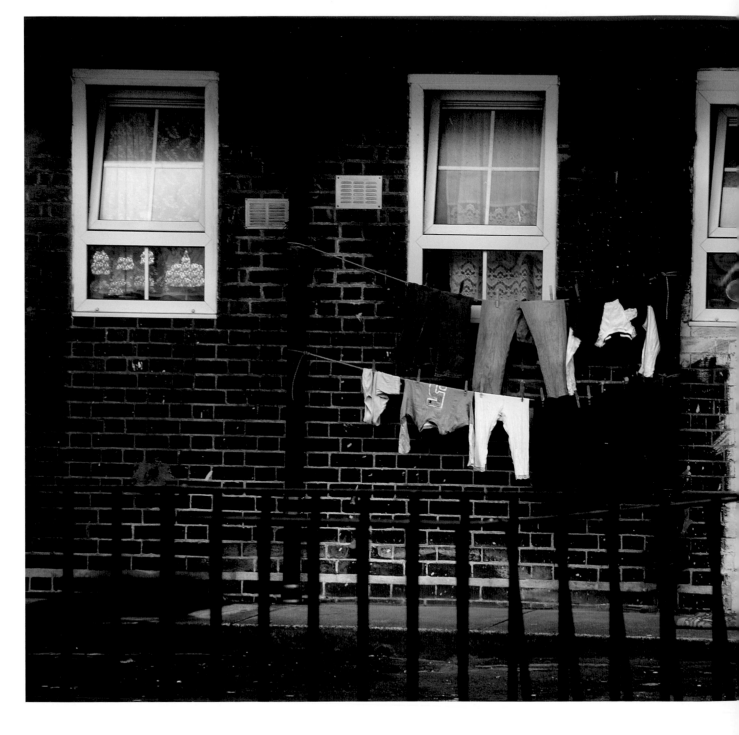

My friends in Iraq would be shocked if I told
them I took this photo in London. They would
not believe that some Londoners live in such
poor housing. It is just like Iraq – the washing
line, the drain pipes, the badly painted door,
the only thing which looked out of place were
the windows, they looked new.

PEEKING THE FULL MOON
BY CHEN FENG CHEN

FIRST CAME TO LONDON: NOV 2005
PHOTOGRAPHIC MENTOR: GAYLE CHONG KWAN

A 'foreigner' lying down in China Town?
Well, in fact we are all 'foreigners.'

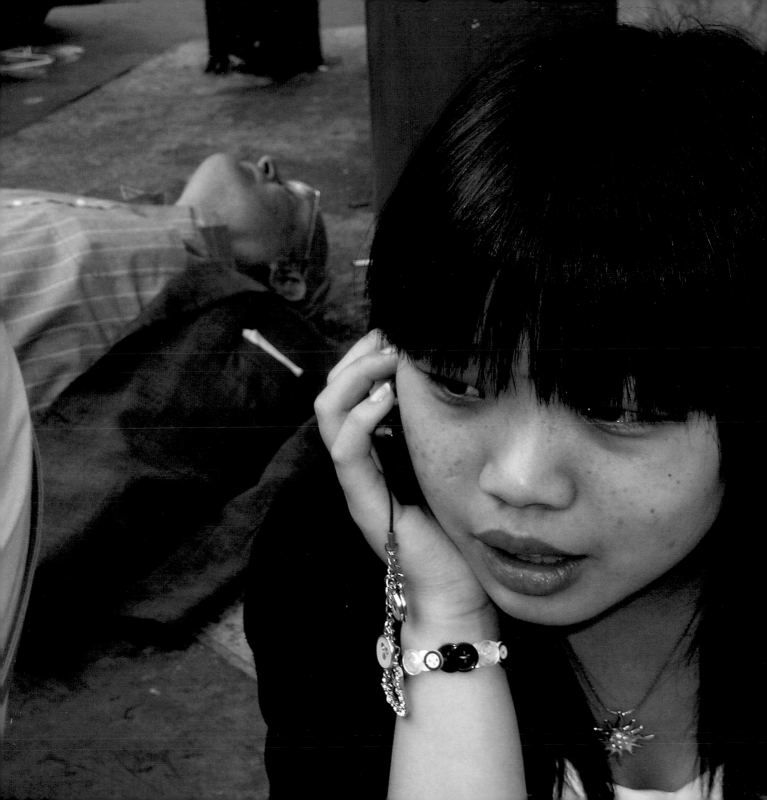

Left Born at a corner instead of on wide grassland. Being alone instead of sticking together. A lonely seed bearing the unchangeable fate grows into a grass like me.

Right Refugees are leaving their homeland for various reasons. They are treated humanely for a short period, but then refugees become a serious problem in civilised, modern countries. Then, they live under the shadow of the sun, hideously and scarily.

Full moon means togetherness for Chinese.
But for me, peeking the full moon at a dark
corner is the only choice.

I always thought I was entering the colourful world of freedom since I left China. But then it turns out to be just black and white. Memory and hope are of the same colour for me.

I can feel the blue skies, white clouds and
light, but I realise that I am surrounded only by
darkness, not by any of them.

Concealing but not hiding, I am still
hoping, watching, keeping the faith.

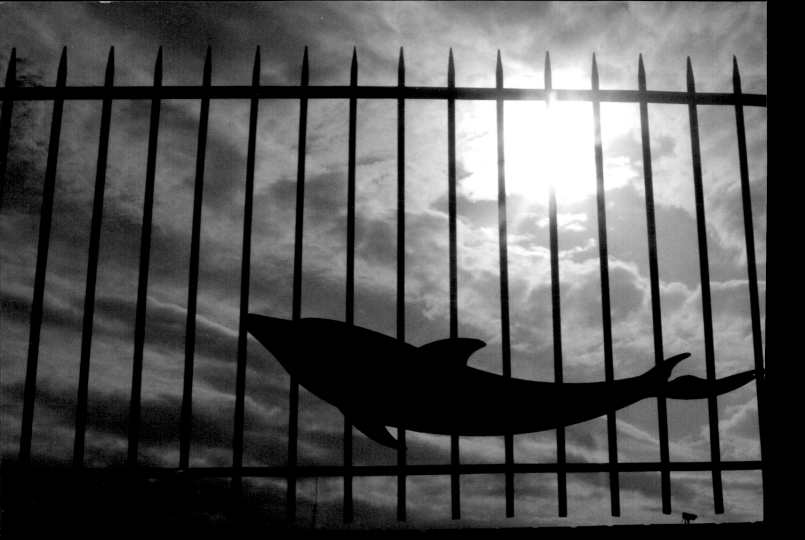

SISTERS IN LONDON
BY DORKY, BERNY AND FLOWERS
FIRST CAME TO LONDON: JAN 2007
PHOTOGRAPHIC MENTORS: SARAH MOON AND ILONA SUSCHITZKY

Flowers This is when I went to Southend with my sisters.

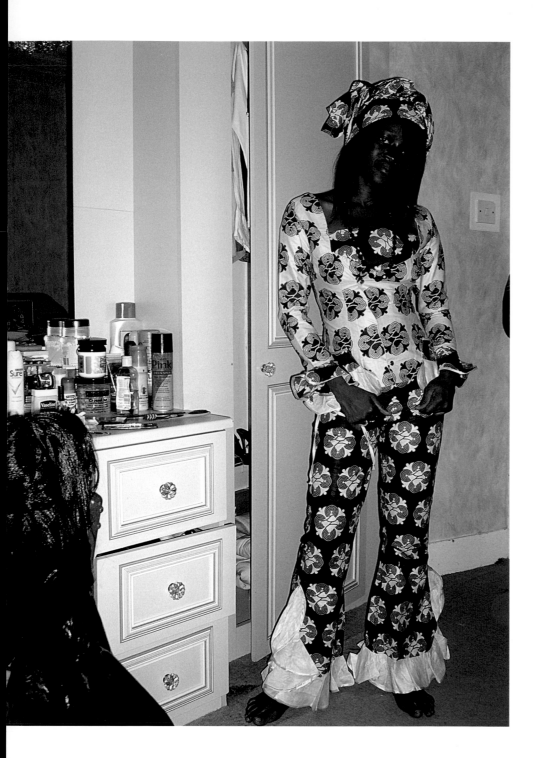

Dorky (left) I think I am really lucky to be African and especially to be Congolese. I feel proud of these traditional clothes. Even though I am in England I will never ever forget or hide where I am from and I will always be proud of who I am. I play the guitar, sing and write songs. I want to be a doctor and open a centre for orphans.

Flowers (right) This picture shows me wearing traditional clothes. I like swimming, basketball, piano and dancing.

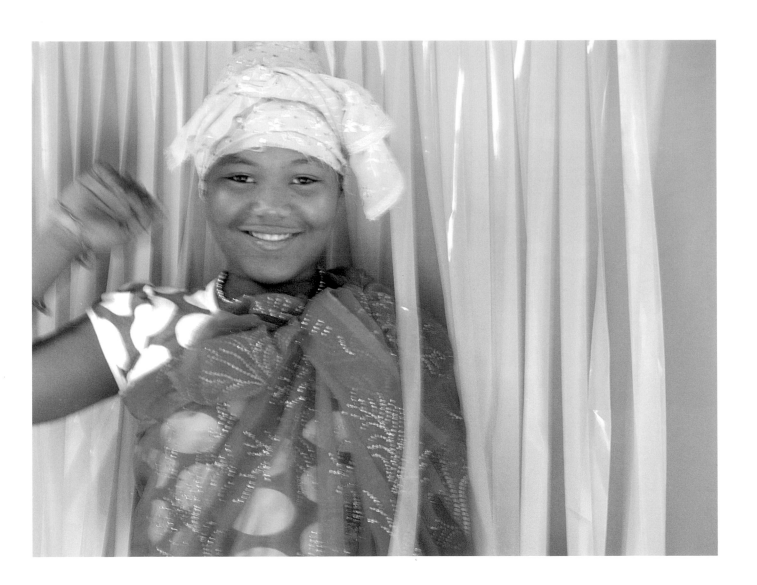

Dorky This picture really says a lot about how I was feeling on my 17th birthday. The blown cake shows how I celebrated my birthday with my friends in the UK. The other, unblown cake, shows how I have a hope that one day I will have a birthday party with my family.

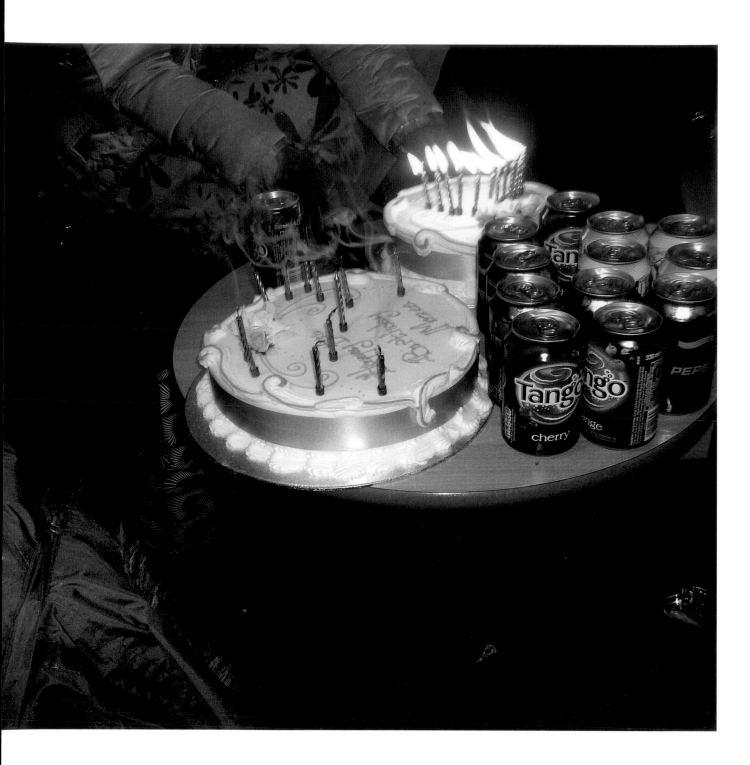

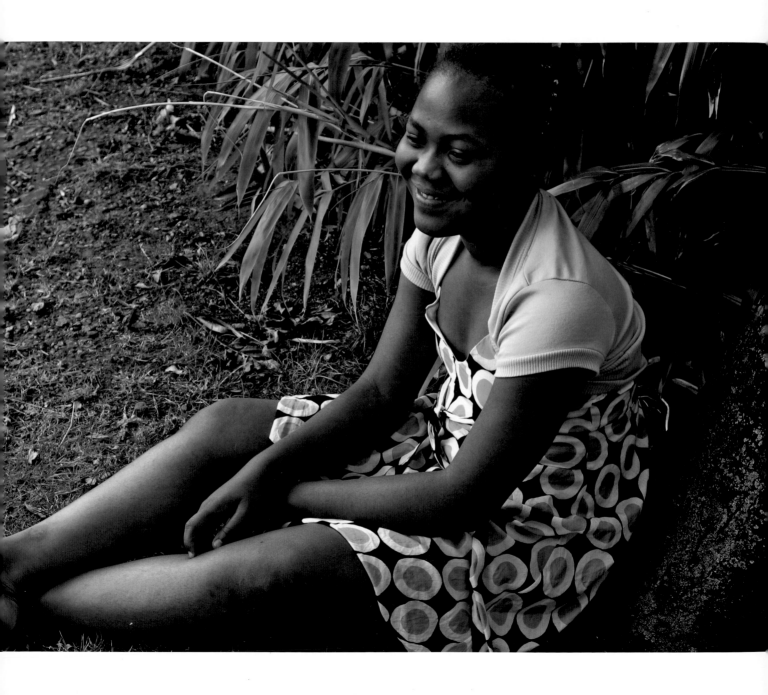

Flowers (left) This is when I was sitting in the park. I like it because I was feeling good. I like the way my clothes are the same colour as the flowers.

Dorky (right) 'My Shadow'
In this country, I feel like a shadow with my real body in my home country; my body is lost somewhere, and nobody knows where. The expression of my hands shows how I feel scared, out of myself and really, really confused about what might happen to me in this country.

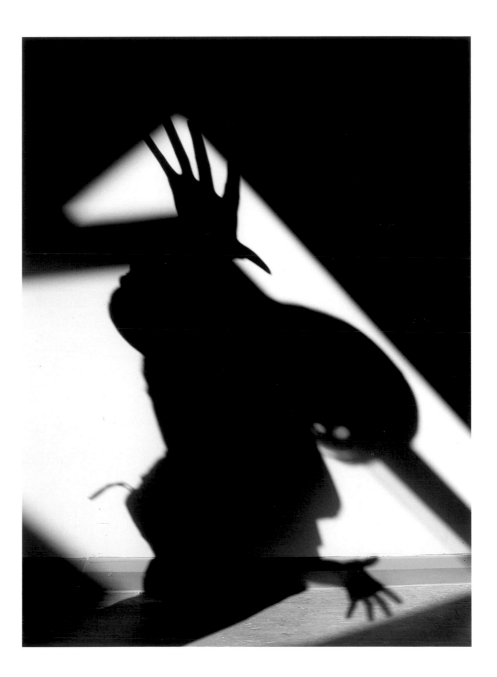

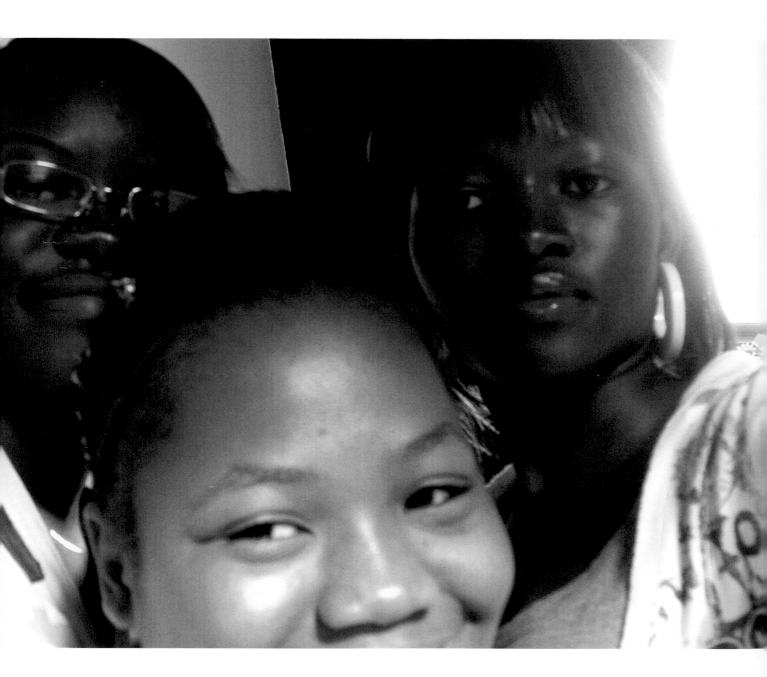

Dorky (left) 'Me with my Sisters'. This picture shows how happy I am when I'm with my sisters. It shows how close we are even though we are far away from our family and country. Being in London is not the best thing that happened to us but still we are closer and no-one can separate us. I don't really know what I would do to be without my sisters in this country. I can only say, "Thank you God."

Berny (right) I like dancing, singing and laughing. I am a funny person. I like being me.

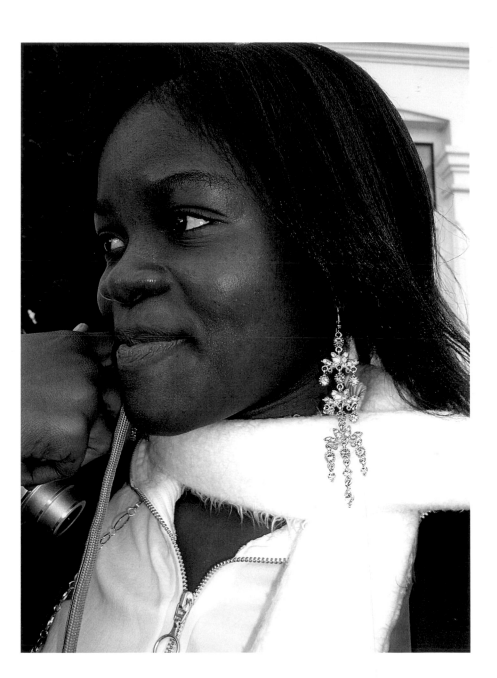

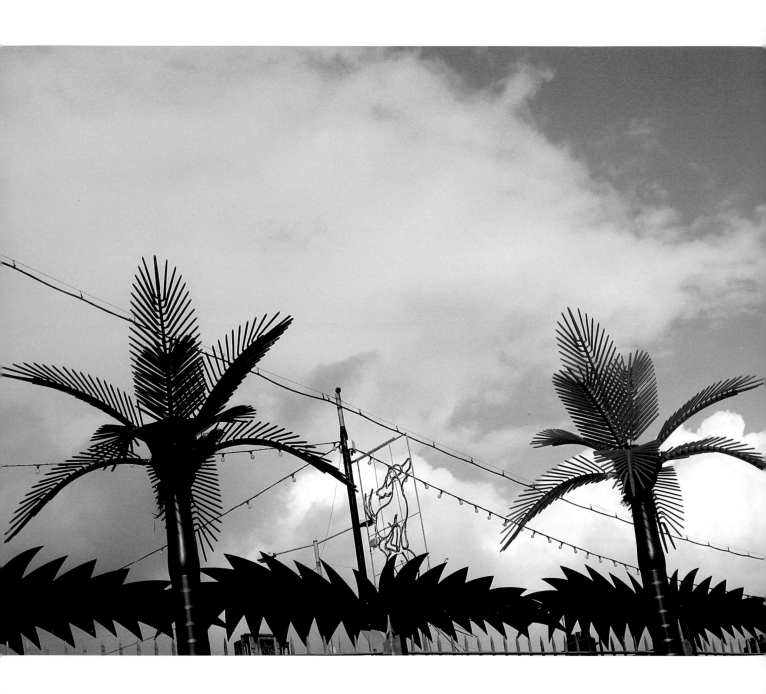

RIDLEY ROAD
BY LAWRENCE STOPWAR
FIRST CAME TO LONDON: 1998
PHOTOGRAPHIC MENTOR: JENNY MATTHEWS

I chose to photograph in Ridley Road market because it stands out in a unique way; the items that are sold and who sells them, the lifestyle of Hackney in general. The market is a place of survival for a lot of people who cannot get a job anywhere else. The strongest thing is the harmony in the market amongst the retailers. It contributes to its growth. In the market you can find people from everywhere getting on with each other, working together.

The very first time I went to the market it was a shock to find different products from all over the world being sold by people from all over the world. It's nice to shop there, it's busy, you feel comfortable and there are lots of different things on sale. As you walk through it you can hear a variety of music from different backgrounds, from the Caribbean to South Africa. And it's cheap compared to the high street, which makes it even more of a pleasant place to shop.

Working in the market shows how surviving in London can be very difficult, especially for a young adult. The whole cycle of life around the market reflects a lot of things about life in London – hard physical work and low pay. You are in a low paid category of society. It's a different experience to working in an office, it makes you determined to achieve your goal. If you're a young adult the difficulties push you to do something else. Many items in the market are sold at cheap prices because they have been imported from countries where people are being forced to work for low wages, countries such as Japan, China and Vietnam.

You get happy people in the market and you get sad people but you don't actually know the truth behind the expression until you get to talk to them. Often you find some people are being forced to work for their family or boss – it's not their choice, it's not under their control. It is sad to live in that sort of situation. At the same time most shop owners also have a sad face because their businesses aren't living up to their expectations.

But if you look at it from another point of view, getting a job in the market is a big achievement and a good break. Many people can't get jobs anywhere else and being employed cash-in-hand is the easiest option and some people prefer it.

In the market there is a range of different shop and stall owners. Some have been there for a long time. I know one man who has spent 37 years working in the market. They love the market and they want their customers to be satisfied. You can see it from the expressions on their faces and their attitude to their customers.

I went back to Ridley Road to see what changes there have been round there in the years since I was first in the country: whether it's still cheap, how it's grown, if foreigners still work for the stall owners. I went to see if the wall in the market still bears the same paint and the same smell. I went to see if crime still continued. I went to see if the sellers still had their regular customers.

I realised how much I have achieved since I worked there and how much that has changed my view of the market. When I worked there I felt trapped by it. Before I never had enough time to enjoy the sunshine of the market.

I worked from 7.30am till late in the evening. I enjoyed going back as a customer. My own understanding is vastly different from other customers as I've worked there myself. I realised how people are still working very hard to keep the market going.

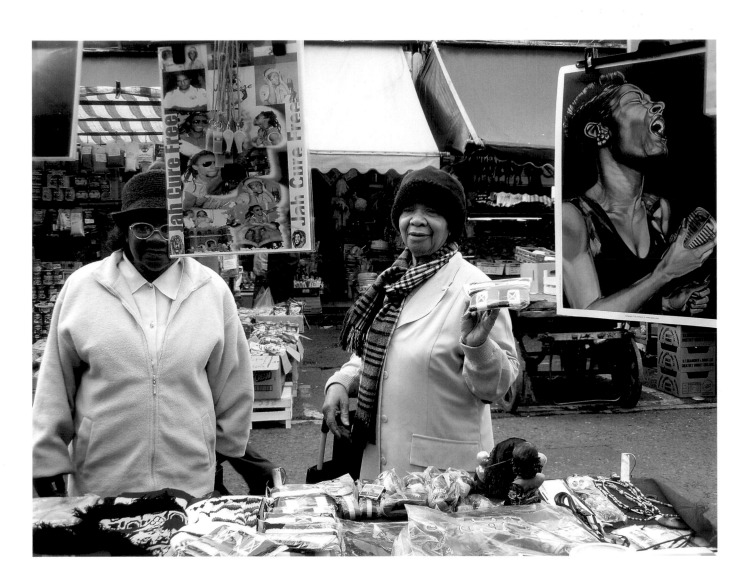

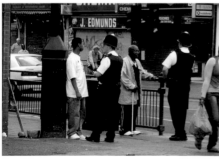

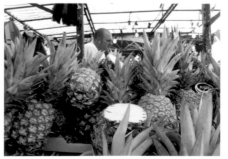

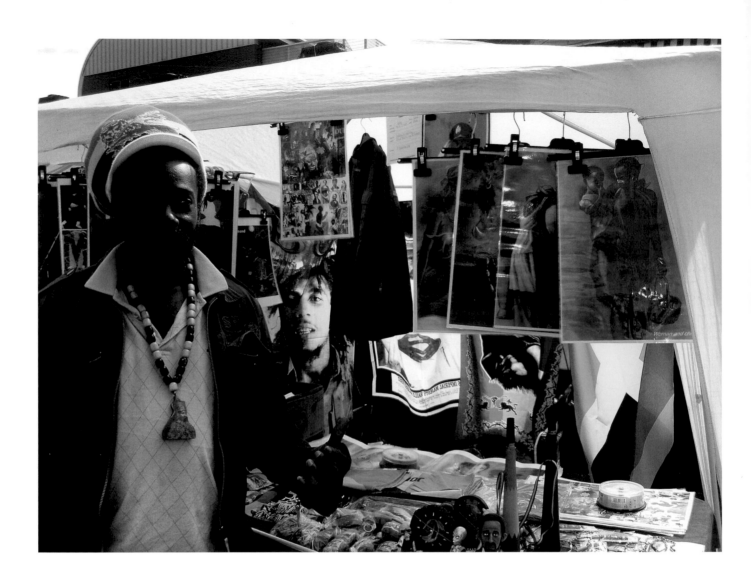

This is Howard from the West Indies, a middle-aged man who sells Caribbean products. He has been running his business for one and a half years and he told me how much he enjoys the atmosphere of the market. Even though he may have a quiet day sometimes, he still enjoys being part of the market.

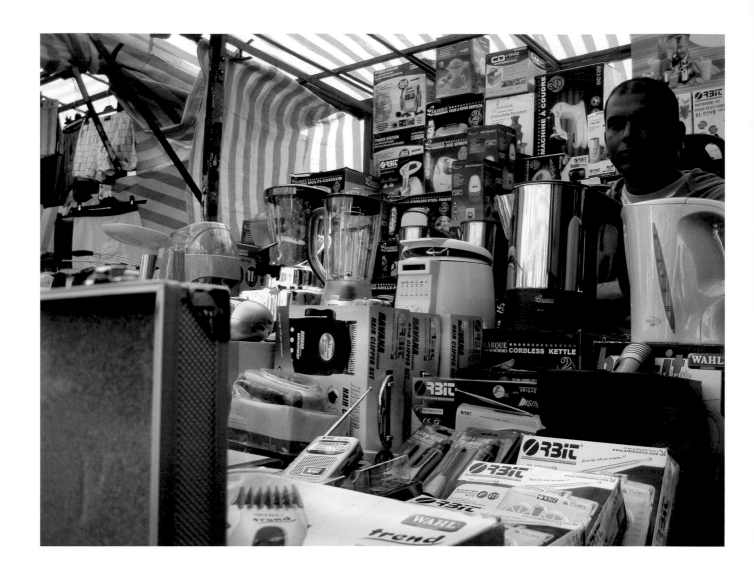

Omar is from Kashmir in Pakistan. He was really interested in my work and suggested that I take his picture. He runs a small business in the middle of the market as well as his family business which is in a shop behind his stall.

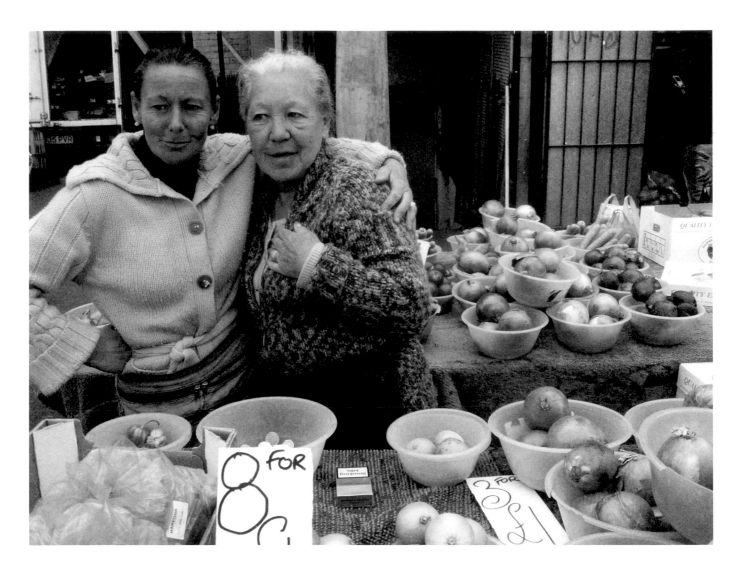

Leigh Mayor is among the individuals who has grown up in the market and knows a lot about it. She runs their family fruit and vegetable stall with a helping hand from her mum and her brother. Most of the people do business for the pride and fun of it rather than large scale profits. Their family business has been running in the market for over one hundred years, according to Leigh.

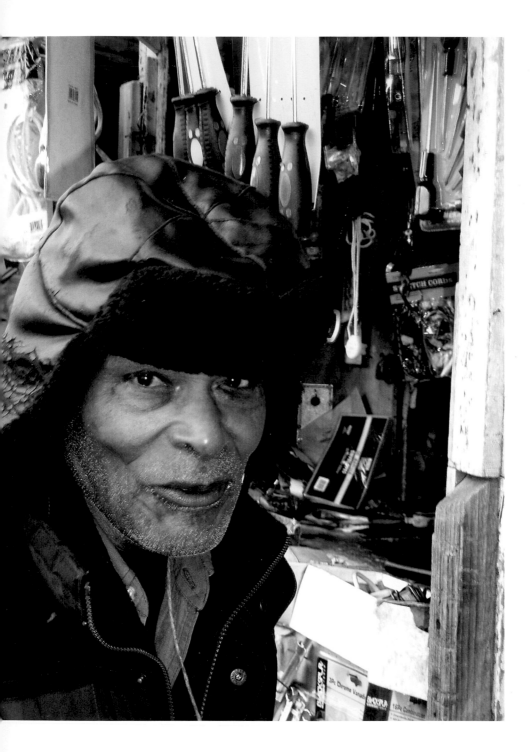

Left This is John. He has been in the market for many years and sells DIY products. Unfortunately for John business is not good and he has found it very difficult to develop his store as he barely makes enough money to survive.

Right This is a typical day in Dalston market, not a celebration or carnival as you might think. But it is a celebration for some of the sellers to sell their food, and for the customers who like to eat 'back at home' foods. This is a typical good weather Saturday when most people have time to shop for their weekly needs. It feels amazing to shop in-between the crowds.

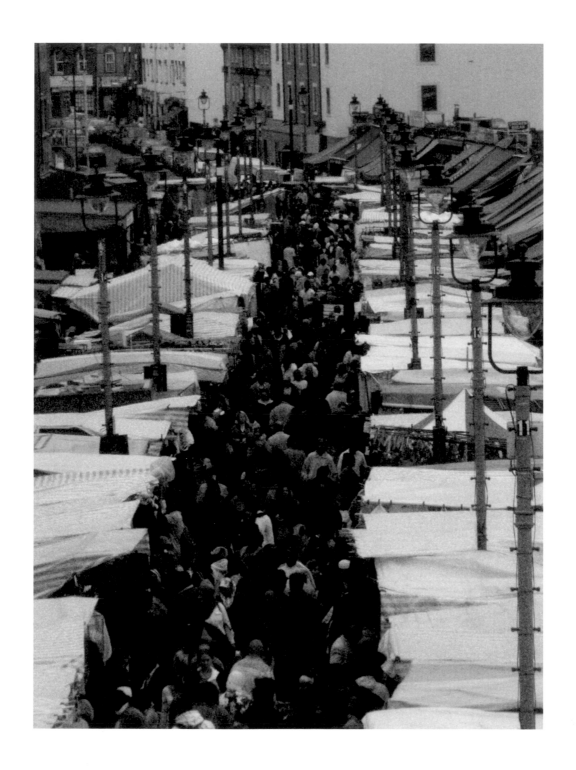

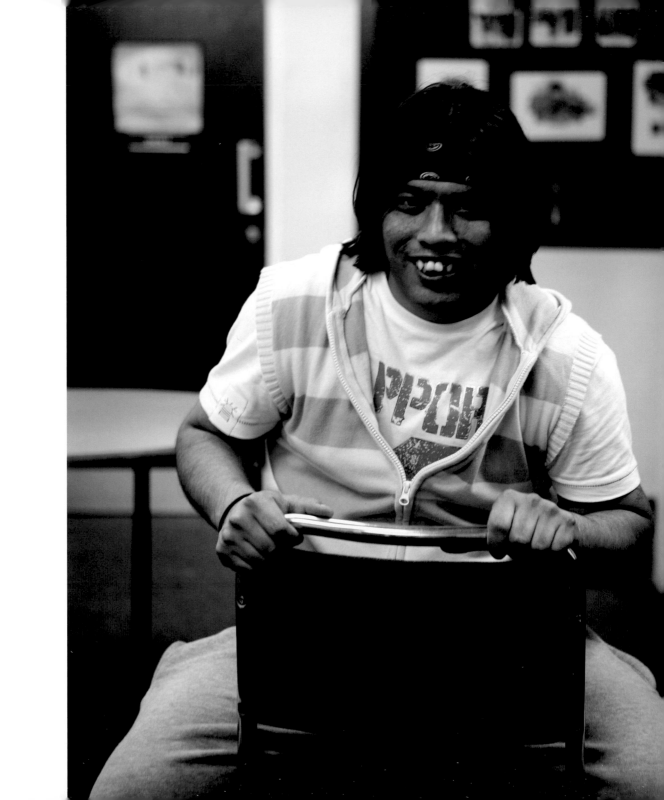

TRINITY AND ME
BY SHARAFAT MARJANI
FIRST CAME TO LONDON: DEC 2006
PHOTOGRAPHIC MENTOR: ANNA KARI

My name is Sharafat. I am myself, I am unlike any other person.
I am from Afghanistan but I now live in the UK. Nice people,
nice country, I am safe here. But it is not easy for me, things in
this country are so hard. I want to build a life for myself here.
Nothing big, but something solid.
I spend a lot of time at the Trinity Centre, I am here nearly every
day, where I get the support of Dost. Trinity is a meeting place
for people of many different communities. These are portraits of
some of the many people who work here and spend time here.
I have been here for 3 years and have been involved with
PhotoVoice for all of that time.
I like photography because photographs stay forever. A hundred
years later people will still see them and remember that this
person did some good, that this person is still here, still standing.

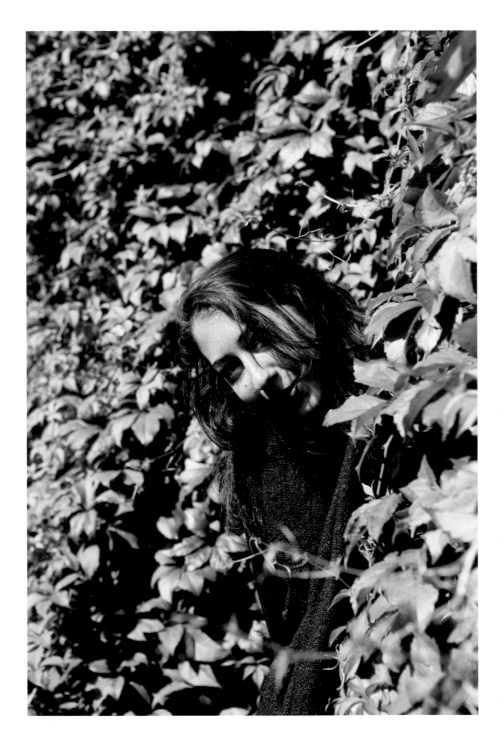

Elhum Trinity Community Centre Trustee

A few weeks ago, Mekdes and I taught one young person from Dost how to cook eggs. He had been living on canned soup since his arrival in the UK. We put the oil in the pan, added some chopped tomatoes, cracked an egg and waited for it to cook.

'It's so easy!' he said, amazed. Then the three of us sat around a single plate and ate it with warm bread. 'It's so nice!' he marvelled. Since then, every time he sees me, he informs me of his latest cooking endeavours. I love that when I come to Trinity, one of the many smiles and hellos I get is this one: 'Elhum, today I made an egg!' It is in this sense that Trinity is a unique – and at times slightly eccentric – place. It becomes a family to everyone, and I too feel I was adopted the very first time I walked through its doors.

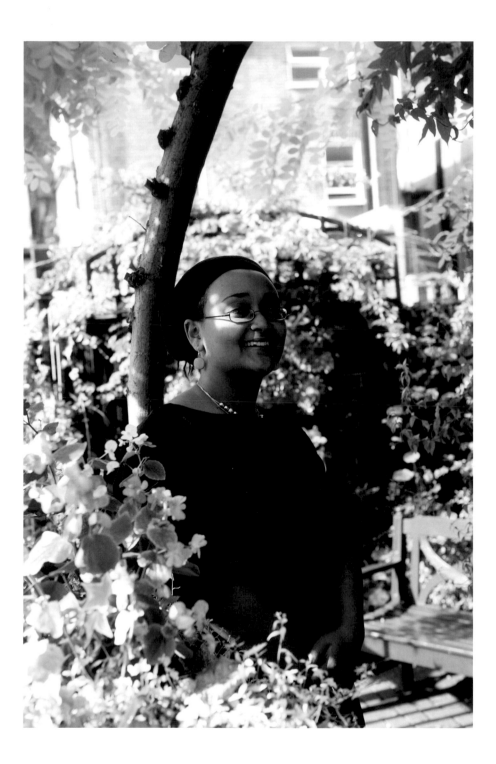

Mekdes Dost Caseworker
The Trinity Centre. It's not your normal
9 to 5! I like it because it's quirky. It's full
of character. It's our own little micro-
community. There are so many different
generations, so many different cultures and
so many different personalities. And it's
just buzzing.

Hassani Sharafat's good friend
Life is good in Britain but it's hard sometimes
because of the language. Sharafat is my best
friend because he has a big heart.

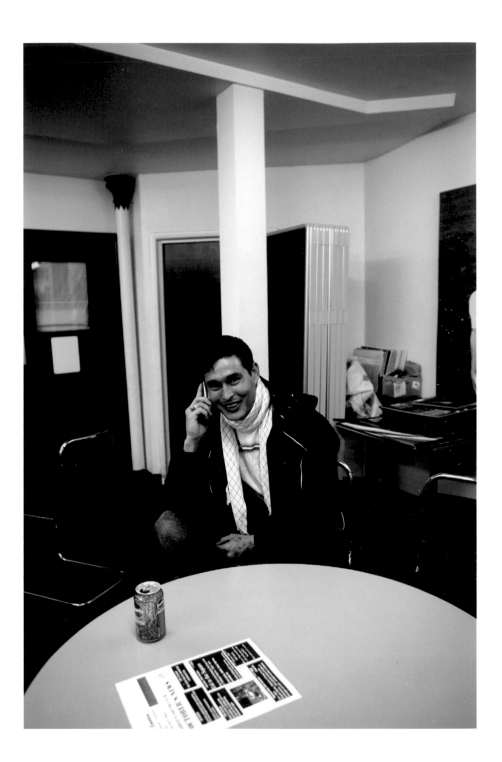

Donald (right) with Emmanuel

Nu-Life for Adults with Learning Disabilities

My dream is to wash cars in a car showroom.
I like to come here because they care for
me. I do exercise, play games and go to the
pub. I like to drink Guinness.

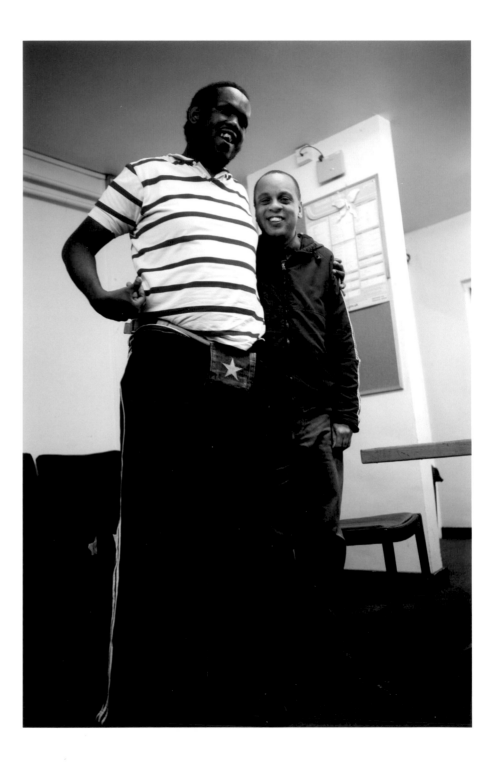

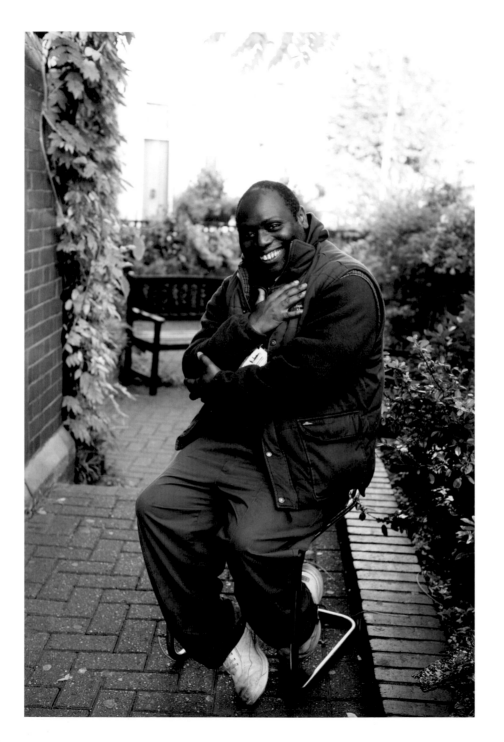

Chuck Trinity Centre User
When I was young, about 15 to 16 years old,
I used to get into trouble with the police.
I was worse than the 'hoodies'. But now I
have grown up and I respect this place. I
have calmed down a lot.

Bali Dost Development Coordinator

I like the way that Trinity creates a sense of home and belonging for people. There is a level of acceptance that allows lots of different people to come together. Trinity is like a root and people come back to us whenever they need us – the door is always open. Some people have been here for twenty years, others have been here for two weeks.

People who come here respect the values and beliefs of others. When you show someone respect, they give it back; that works from the pensioners down to the kids groups. We are based in the middle of a concrete jungle, but out the front, we have a beautiful garden, so people feel welcome the minute they walk through the gate.

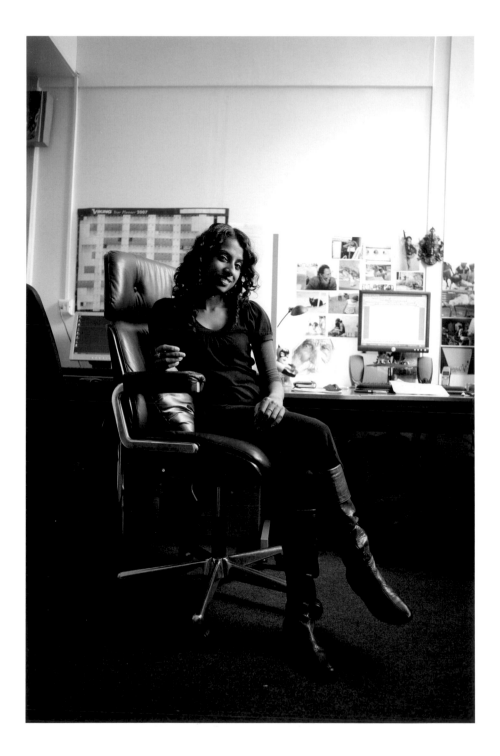

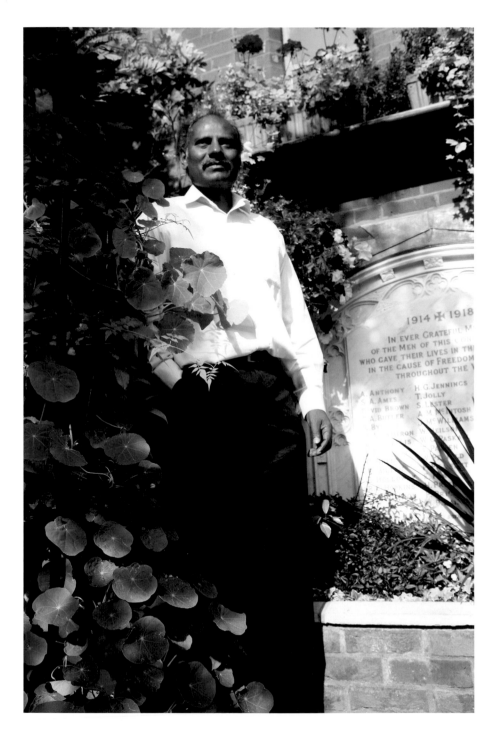

Paul Operations Director

Until I came to the UK, I didn't know that it had such huge problems with communities. I saw the UK as a great empire. To see so many people suffering changed my perception about the UK. By coming here, my life was turned upside down. Before coming to the UK, I had four servants – I didn't even have to do the cleaning. But the first job I was asked to do when I was a volunteer here was the cleaning!

I feel so privileged and honoured to be here, and to serve the community. This centre receives between 2000 and 3000 visitors each week, and it is used by 40 to 60 different groups each year. It gives me a great deal of joy and happiness that individuals and communities can establish themselves and go forward in life.

Colin Dost Education Coordinator
After many years working in schools I now
feel that working here I can achieve that
which schools aim for – integrating the
pastoral work with the academic. Here you
are dealing with every aspect of the young
people's lives. This makes the work very
rewarding and means we establish very
strong relationships.

Dana Caretaker

It was my first job in England. When I came here, I couldn't speak English – you know, only 'hello' and 'how are you?' – so everybody would just point at things. My husband comes to get me because I finish at 10pm and he always brings Tobis, our dog. The dog plays very good football. Everyone loves watching him running around after the ball. When I go back to my country on holiday, I miss this place, I can't wait to get back! It is a very important place, like a second home.

Mr Joshi Coordinator, Punjabi Pensioners' Group

I came by sea from Bombay to Dover. In order to work at the Post Office, I needed references from my doctors and teachers, my immigration papers, my high school in India, even from the Italian boat company that brought us over. It took me months to find my references so that I could get my job.

I have been running tea afternoons here for the Newham elderly Punjabis for 13 years, from 1pm to 6pm every day. We boil light, old-fashioned tea. The problems the users have are common. They are lonely in the house – children go to school and adults go to work. When they come here, they are looking forward to it. They are secure, they are warm in this lovely place.

THIS IS ME
BY QASIM GUL
FIRST CAME TO LONDON: DEC 2006
PHOTOGRAPHIC MENTOR: ANTHONY LAM

This is me. I like to be happy. To have good days.

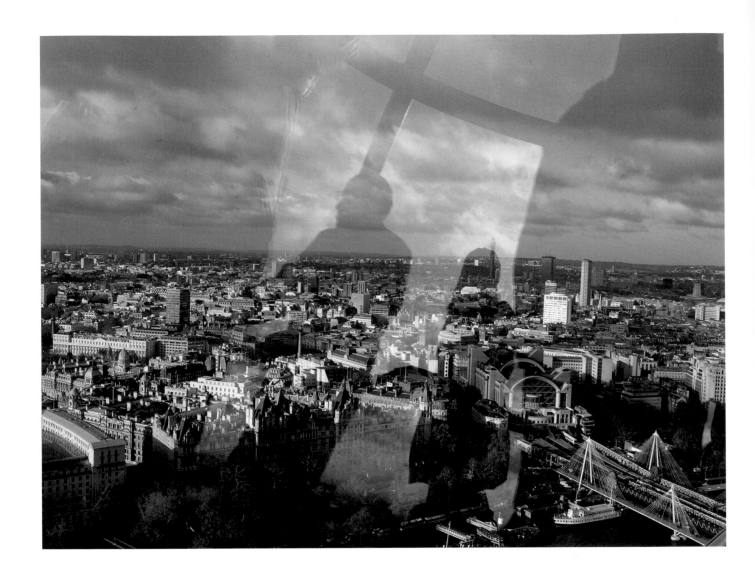

This is London from the London Eye.

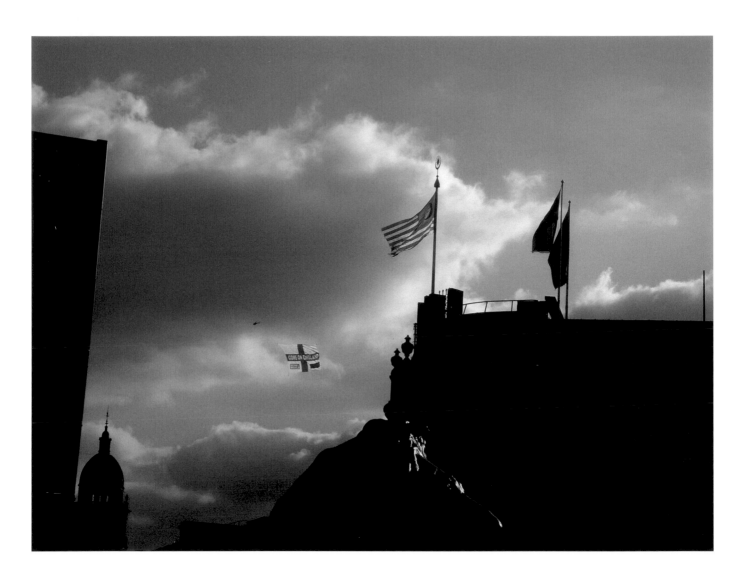

This is the England flag. Next to it are the flags
of other countries. It was the day of Eid that I
took this picture.

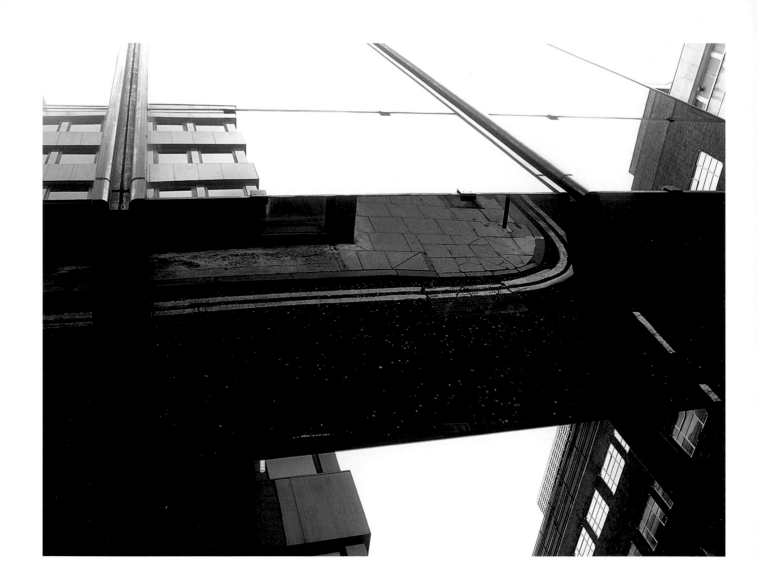

You can hardly tell where this picture is taken.

This is near St Paul's Cathedral. Their shadows have stretched under the sun and they look like very big people.

Left This is outside Green Street mosque. It used to be near my house and I took this photo when I was walking home one day. All the shoes are by the door because it is a prayer house.

Right This is Akhtar. Everyone told him not to go up but he did. In our language "to be a lion" means to be courageous.

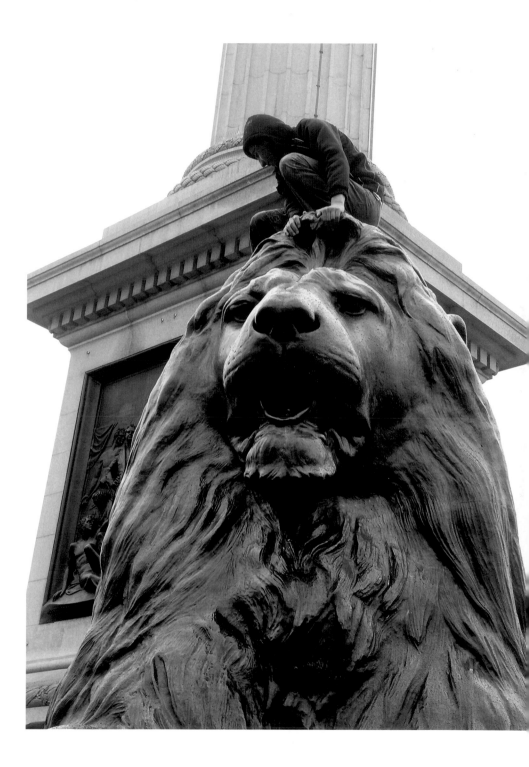

THE CONGOLESE YOUTH BAND
BY IVANO KANKONDE
FIRST CAME TO LONDON: 2004
PHOTOGRAPHIC MENTOR: OTHELLO DE'SOUZA-HARTLEY

The man on the left of the picture is my friend. I have known him for four years. Him and the band – the Congolese Youth Band – are very talented musicians. A while after we first met, we ended up living together, along with the drummer as well. One day they asked me to make a video of them with a camera they had bought. They were singing along to songs they had taped from the radio. I thought it was very funny. I had never handled a camera before. We made the video in the house. Sometime later I got involved in a photography project with MTV, through the Refugee Council. After the project they invited us to an MTV show in Leicester Square. That was the day I first had the feeling that I wanted to do something in film and photography.

I go to hear them play once or twice a week in Brixton. They play modern Congolese music, called Soukous – of which ndombolo is a very popular style. The music comes from Kinshasa, the capital of the Democratic Republic of Congo. I like dancing. The rhythms are hard and fast. You can lose yourself in the music. I understand everything they sing about – they sing about life and they sing about love. Everyone there dances, we all dance in our own way. There are people from Congo, Cameroon, Ivory Coast and sometimes, but not very often, an English person. If you come and hear the music you will stay to the end, you will never get bored!

I arrived in London four years ago. It felt like a safe place for me. Back home they always said about England that 'time is money.' It is true. Everyone here is so busy. I have some good friends, but they are also very busy. It is good here, but it is not easy as a young person trying to achieve your goals.

I am studying film projection at college. I would like to go to university and my ambition is to be a TV cameraman.

A big thanks to the Congolese Youth Band who gave me the chance to work with them on this project.

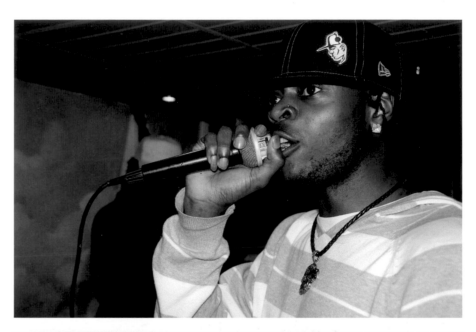

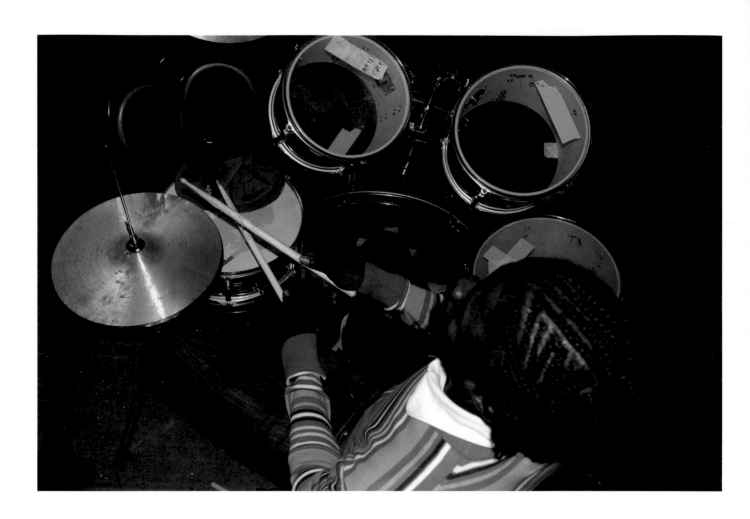

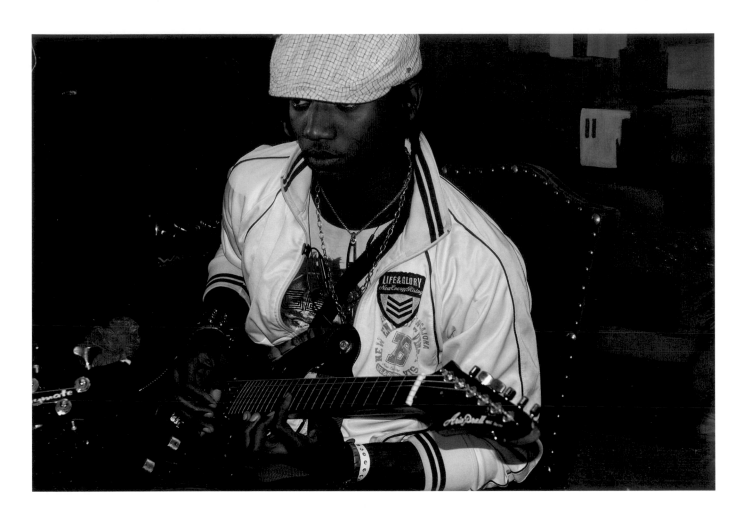

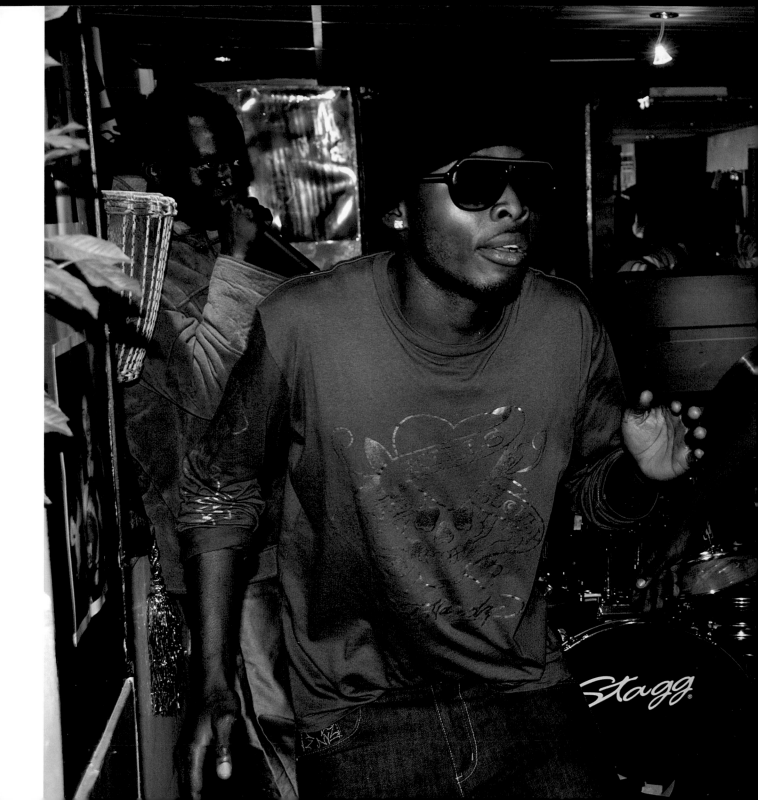

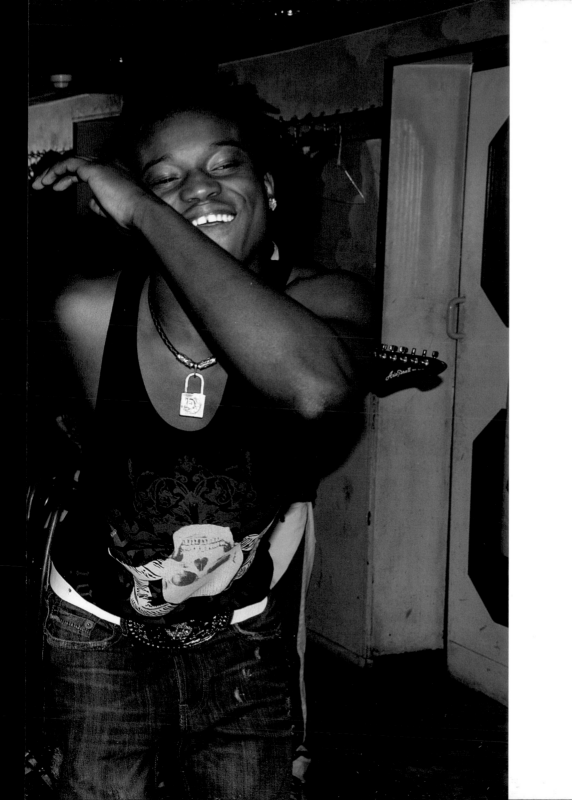

NEW CITIZENS
BY TATIANA CORREIA
FIRST CAME TO LONDON: 2001
PHOTOGRAPHIC MENTOR: JILLIAN EDELSTEIN

I had my citizenship ceremony last summer and to my surprise it was quite emotional. The Town Hall provides a lovely service and makes sure citizens are made to feel welcome and appreciated. It feels like a very positive symbol of 'real' multiculturalism.

On the day I could not quite understand why we had to do all the different bits of the ceremony - including singing the hymn and pledging allegiance to the Queen. Many people there did not know what was happening due to language problems. I started thinking about what the whole process of citizenship means and about how these ceremonies are part of the changing and evolving process of modern societies.

Behind the celebratory mood, I was suddenly aware of the contradictions between nationality and citizenship. A nation is often understood as a group of people who believe they have a common heritage and destiny. However, citizenship is like a newly-acquired national identity. It is an important change and transition in people's lives. People from all over the world, for different reasons and with a culture already, decide to become part of a whole new one.

I have an interest in how the ceremony affects and shapes one's personal identity, and in how it is reshaping communities in cultures that are established already. I also wonder how the apparent 'equality' being given to the new citizens will affect the obvious cultural, financial and social inequality. Only the future will tell but at the moment it is a privilege to be present while such developments take place.

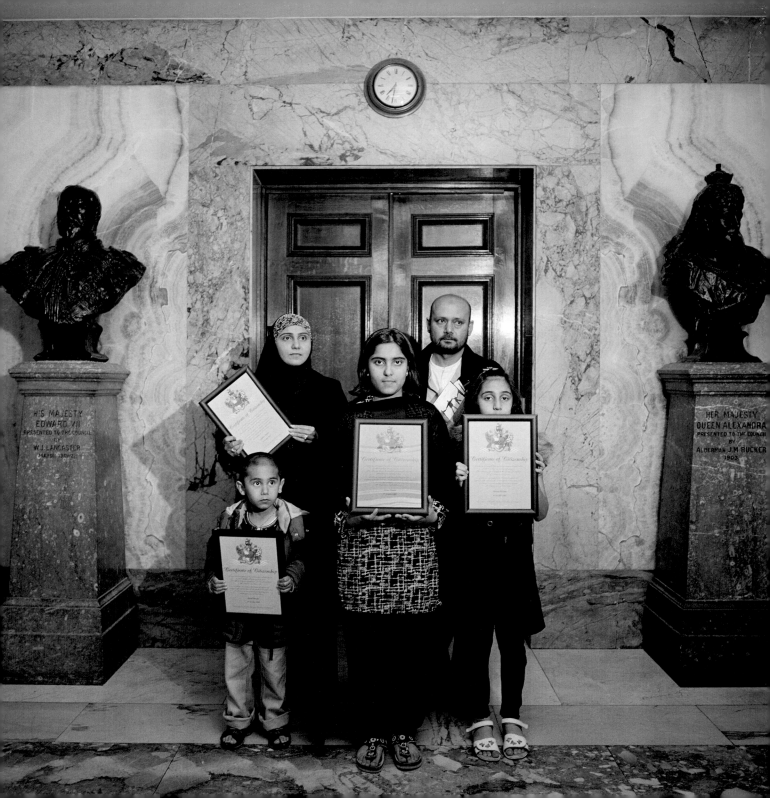

YOUNG SEPARATED REFUGEES : A CONTEXT

Since the year 2000 more than 15,000 young separated refugees have arrived alone in the UK seeking sanctuary.

Most of these young people arrive in the UK in a state of shock and confusion; many have endured extreme events as a result of armed conflict or political or religious persecution. Many have witnessed the violent death of parent(s) and family, some have experienced detention and torture, genocide, persecution due to ethnic or religious identity, trafficking for the purposes of exploitation, forced recruitment into armed forces, forced marriage, rape and sexual assault, female genital mutilation, abuse, abandonment or poverty. All have lost their homes. All are separated from their families and are in need of protection. This book uses the term 'refugee' to describe all young people seeking asylum as well as those who have been granted limited leave to remain. In exile, young separated refugees suffer greatly from the loss of all that is familiar; home, family, friends, community, language, culture, and way of life. Due to the heavy weight of their histories and the precariousness of the present, they are extremely vulnerable. They face a multitude of challenges as they adjust to life in the UK : language, their asylum claim, accommodation, budgeting, self-care, rebuilding a support network and accessing education, health and social services. As people subject to immigration legislation, they have little control over their future, and live in constant fear of eventually being returned to the countries they fled.

The UK has a clear obligation to safeguard and promote the well-being of separated children in accordance with UN Conventions and UK legislative frameworks. Although basic physical and financial needs are usually met by social services, the level of support they receive is often arbitrary and depends upon the resources and capacity of the professionals they come into contact with. As a result, many of them do not have the consistent support and guidance of a responsible adult, and often carry the burden of both past and present alone. However, these young people are survivors; it is a testament to their strength and courage that despite their struggles they continue to hope, to live and dream of a better future.

"New Londoners demonstrates the poignant aspirations and the courage of people who have had to live with extraordinary uncertainty. The pain of losses generated by violence in countries of origin; the desolation of being uprooted from the familiar and plunged into the unfamiliar; waiting for visas and papers.

In the midst of this insecurity new relationships are formed. This book offers an example in which both the young people and mentors have been able to share experiences and learn from one another. The result of this creative collaboration is a wealth of ideas and development of a common language from which we all benefit. Everything in the world is inter-dependent and part of a systemic 'whole.' If one person is getting richer and the other is suffering, the equilibrium is disturbed and both are impacted. Only the thin line of economy divides human destiny. For all of us there are times when we are vulnerable and it's a mistake to think that vulnerability is a failure. We all deserve the dignity of being cherished."

Camila Batmanghelidjh
Founder and Director of Kids Company

THE NEW LONDONERS STORY

New Londoners is the latest in a series of award-winning photography projects that PhotoVoice – in partnership with Dost – has run for separated refugees in East London since 2002. PhotoVoice opens up a world of creative opportunities and a platform for self-expression for the young refugees. Dost facilitates this emphasis on creativity through its practical, therapeutic and advocacy support to the participants.

The New Londoners mentoring scheme began in July 2007 when 15 young refugees were partnered with 15 emerging and successful London photographers to make a photo story on the theme of New Londoners.

The young participants, aged thirteen to twenty-three, came from nine different countries, with diverse experiences and backgrounds. Some had been in the UK for just 6 months when they joined the project, others for as long as six years. They had all been participants on previous photography projects and were selected as mentees for a variety of reasons : their potential as young photographers; their commitment to and interest in a creative challenge; and their openness to a new relationship. The matching process was given significant consideration, but there was also an element of chance. People were partnered based on an obvious common interest such as a place or subject; a leaning to a particular style of photography; the photographer's knowledge of the mentee's country of origin; a shared cultural interest; or a similar attitude to a particular way of working.

The photographers and young people met up with each other over a four-month period in late 2007. The main focus was the production of a creative body of work by the young person. Typically the young person would shoot in their own time, and would meet up with the mentor to review and edit the images about once a fortnight.

The role of the mentor was to listen to, support, affirm, advise, enthuse and encourage the mentee and to enable them to reach their full photographic potential. The mentors helped nurture the mentee's confidence in their own photographic ideas, and bring those ideas to life. For many of the young photographers, finding their photographic voice was not an easy or smooth process. The body of work built up slowly, like an ongoing conversation with the city around them.

Most of the mentors felt they had gained as much as they had given in this project. They felt they had learned not just about another person, but more about themselves, the image-making process and their city. Photography is full of potential as a tool for integration. It can help explore and construct new identities; build memories; communicate ideas and points of view; negotiate new and unfamiliar places; and facilitate discussion and dialogue. In doing so, photography plays a part in the process of putting down roots.

The project had its highs and lows. Three participants won full citizenship rights late in 2007; two young people had to pull out. There is also another side to this project, one that you don't see so clearly in this book. The lives of young separated refugees in the UK, especially the newer arrivals, are characterised by a complex, bureaucratic and time-consuming engagement with the asylum process, involving a constant series of appointments and meetings with solicitors, social workers, housing and education officers, and other support workers. It's not easy to sustain a photography project. For the more established participants who have lived here for longer and are all over 21, the pressures of work or studying meant the project got pushed aside from time to time. Also, participants would sometimes need to prioritise something else – hanging out with friends; having a lie-in; playing football; going to church.

Generalisations about the value of a project like this are hard to make as the young photographers have differing needs and equally have had such a diversity of experiences. For many of the them it supported their integration by enabling them to improve their language and communication skills; to form a new and supportive relationship; to get to know London; to have a means of expression for feelings and ideas; to achieve something to take pride in; and feeling valued and respected as a person. All of these elements have enabled them to grow in confidence and build their lives in the UK.

A WORD FROM THE PHOTOGRAPHERS

FENG: Gayle is like a teacher, like a friend and sometimes like an older sister. I enjoyed taking photos with Gayle in China Town. Before, I didn't have any knowledge about cameras or photography so I just tried and learnt. It's quite nice, quite great. I can go out and take my camera and capture the history of the moment. I like to catch the moment because afterwards it is gone. And after a period of time it will become history – you can show young people after many years, my ideas.

GAYLE: My work with Feng became more of a conversation between us, with photography as one of our main languages. It was a pleasure to witness his growing confidence in expressing himself through his photography, and he revealed new and richer perspectives to me : in regards to his experience of living in London; of China Town, where he developed his project; and in regards to my own Chinese heritage. I feel privileged to have worked with Feng.

CHALAK: If I speak about Jo, she changed my brain about photography. She's a very good teacher and a very good photographer. For me photography is now very serious. When I pick up a newspaper I always look at the photographs first. I like photography, if I get a visa and get refugee status here, this would be a good job for me. I feel like the photography is mixed with my blood.

JO: Chalak and I still meet nearly every Sunday at the Tate. I am teaching him Photoshop. The relationship has really moved on from when it all started. It was really hard at first, as he was really down. He found it hard to do anything, he said "It's like I feel hungry but I can't eat." We have found more and more common ground between us, and he has settled a bit more. It feels like a friendship within the realms of me being his photography and English teacher. I think what he values from me is that I am different from all his other 'meetings' with people. I am just an ordinary person with a disorganised and busy life, who values him for who he is. It's about photography not asylum.

LORIA: We are new photographers and New Londoners. Being in a book is a big thing for us. It helps us to show how we are the same as other people, even though our pasts and our experiences are different. My personality is the same as it was in the Congo. Some people say bad things about us, they make judgements about us because we are refugees. They say we come here for reasons like education and income support. But we did not choose this life. I want to show who I am and why I came here. Photography has been a therapy for me, I learned how to break free of myself. Working with Liane has made me really happy.

LIANE: Loria and I would often burst out laughing whenever I tried to play the role of mentor. Not out of any disrespect, but she was often the wiser and more mature one, offering me advice about things that she just intuitively recognised I was struggling with. She embraced photography with the same commitment, curiosity and sense of humour that she approaches most things in her life with. So at first she was pretty timid with the camera and taking portraits of people. But very quickly she was shooting like a pro, just totally in the moment, trying to get that perfect shot.

MUSSIE: I want to be a free person in this country, to be equal. This photography, this book, gives me a voice to show others the way of life of a New Londoner. This is important for me as even a great person like a prime minister might not know about our situation, and needs to learn. This is our chance, we are making a piece of history. Crispin has been so very helpful, respectful, punctual and honest. I have learnt how to take pictures with him.

CRISPIN: We regularly met outside Downing Street. I think Mussie was rather taken with the place being an ordinary street house with a number rather than an unapproachable palace. One day I turned up and there was no sign of him. Mussie is always very punctual. Finally he called, and explained he was over the road. It was only when I looked more closely at two rather large and heavily armed police that I saw the small but stylish figure of Mussie standing between the two of them. I crossed the road and vouched for him in my best manner. It seems they had become quite suspicious of him hanging around Downing Street for so long and had started questioning him. He had explained that he could see me over the road, but they wouldn't let him call me. This was Mussie's first brush with the law here and it ended with smiles all round and the officers giving him the paperwork he photographed himself with once we were up the road.

PHOTOGRAPHERS / MENTORS

 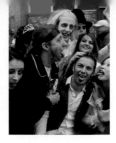 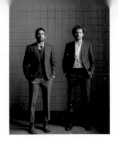

Al-Mousaoy

I am from Baghdad in Iraq. I came to London on the 1st of December 2006 and I don't like it here. When we used to hear about England , we would think that it was an amazing place, but living in England , you see the difference. There is a big difference between what you hear and what you live. Life here is very hard. You don't have your family with you. People come to this country because they want to live, they come with a reason. My reason was that there is a war in my country.

Suki Dhanda

is a London-based photographer specialising in portraits of people in their environments. Her editorial commissions are regularly published in magazines including the Observer, the Sunday Times, the Telegraph and the New York Times. She has held numerous exhibitions. A recent series focuses on first person accounts of migrant workers employed as cleaners in London.
In 2006 her portraits exploring the relationship between dogs and people, commissioned by Platform for Art, were shown across London Underground stations.

Bajram Spahia

I am 22 years old. I am Albanian and I was born in Serbia. I first came to the UK in 2001, and last year I was awarded British citizenship. My passion is film-making and I currently work as a videographer.
One day I hope to be able to make my own films. I also love photography; I am happy as long as I am learning something new.

Adam Broomberg and Oliver Chanarin

have been collaborating for over a decade and are still friends. They have produced five books which in different ways examine the language of documentary photography; Trust, Ghetto, Mr Mkhize's Portrait (all published by Trolley Books), Chicago, and Fig. They have exhibited internationally, including at the V & A Museum, the Hasselblad Centre, the Photographers' Gallery, and The Stedelijk Museum. They have received numerous awards, including the Vic Odden Award from the Royal Photographic Society, and are trustees of the Photographers' Gallery and Photoworks.

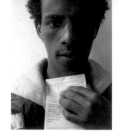

Mussie Haile
I come from Eritrea.
I am 17 years old. I
arrived in this country
on the 8th of Decem-
ber 2006. I like this
country. For example
its transportation,
and the snow – I had
never seen this kind of
weather before in my
country.
I am very happy when
I am here, London is
my new home.

Crispin Hughes
Active consent is
characteristic of Crisp-
in's photography of
social issues, working
to make uncontrived
but collabora-
tive pictures. He
has worked across
Africa for numerous
aid agencies and his
work appears regularly
in the national and
international press.
He has had solo shows
at The Museum of
London and Photofu-
sion and has also been
exhibited at the Pho-
tographers' Gallery,
the National Portrait
Gallery, Camerawork
and at Impressions,
Candid and Metro gal-
leries. He is a founder
member of Photofu-
sion and a member of
Panos Pictures.

Lawrence Stopwar
I am originally from
Nigeria, and came to
the UK in 1998 without
knowing the reason
for being brought
over. I assisted my
auntie at her grocery
shop in Dalston mar-
ket until I got a school
place in east London.
I did a degree (BEng
Hons) in Aeronautical
Engineering, and am
now studying to be a
Mental Health Nurse
at the University of
Brighton. I have a
passion to care for
people in need, just
as I was cared for
when I was in need.
I have volunteered
for a number of
charities such as Save
the Children and the
Children's Society,
and worked in jobs
from assistant chef to
cashier at Superdrug
to support my studies.
I feel settled in the
UK and proud of all I
have achieved without
parental support.

Jenny Matthews
is a photographer and
teacher. Since 1982
she has been docu-
menting social issues
in Britain and abroad.
She has done a major
project on Women
and War which
resulted in a book and
touring exhibition.
She has worked for
leading international
development organi-
sations (ActionAid,
Christian Aid, Oxfam,
Save the Children)
and her work has been
published in major
magazines and news-
papers throughout
the world.

Loria Siamia
I am 17 years old and
I come from Congo.
I arrived in the UK on
the 19th Dec 2005.
I live in Streatham
Hill with my foster
carer. I feel good,
happy and safe here.
I love going to the
cinema, going to res-
taurants, being around
people, surfing on
the internet, watch-
ing movies, listening
to music and eating
chicken and chips.
My dreams are to be
next to my family and
to finish my studies.
I believe education is
the key to success. I
hope to become one
day a successful social
worker and nurse.

Liane Harris
picked up a camera
fifteen years ago and
decided to make her
living as a photogra-
pher. One year she
would be shooting
documentary stories
for the Mayor's office,
and the next would
be spending a few
years as an editorial
photographer working
closely with a journal-
ist. Four years ago she
discovered participa-
tory photography,
which she describes
as giving her the privi-
lege of using her skills
as a photographer to
work on projects with
the most amazing
young people she
has ever met. She
now splits her time
between these two
practices.

PHOTOGRAPHERS / MENTORS

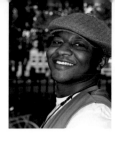 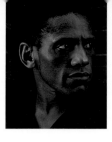 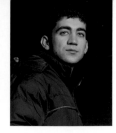 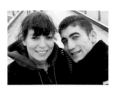

Ivano Kankonde
I come from the Democratic Republic of Congo, and arrived in London four years ago. It felt like a safe place for me. Back home they always said about England that 'time is money.' It is true. Everyone here is so busy. I have some good friends, and even they are also very busy. It is good here, but it is not easy as a young person trying to achieve your goals. I am studying film production at college. I would like to go to university and my ambition is to work in TV programming as a cameraman and editor.

Othello De'Souza-Hartley
is a London-based photographer and artist. In 2000, he completed a Postgraduate in Photography at Central Saint Martins College of Art and Design. As well as working commercially as a fashion and portrait photographer, he is a practicing visual artist. Othello has participated in numerous solo and group exhibitions in London. He has worked on projects commissioned by The National Portrait Gallery, Platform for Art, The National-Trust, The Victoria and Albert Museum and The Camden Arts Centre.

Chalak Abdulrahman
I am from Kirkuk in Iraq. In Kirkuk, the people are poor, but the city is rich, it is first in the world for petrol. When I first started PhotoVoice workshops, I didn't know anything about photography. I like photography, because it is like telling a story. I have many good ideas of photographs I want to take, but I still haven't been able to take the photographs that are in my mind. We are new in this country and we aren't happy. We can't take pictures when we're unhappy. Like sometimes when you are hungry but you can't eat. When I will be happy, I will be able to take those photos.

Jo Metson Scott
is a photographer based in London. She shoots a mixture of portraiture, documentary and fashion photography both in London and abroad, and works regularly for The Telegraph, The Guardian and i-D. Jo started working with PhotoVoice in 2006 on the Moving Lives project in east London, and she continues to meet Chalak regularly for photography lessons.

Shamin Nakalembe
I am 20 years of age and I arrived in England in December 2003. I am currently undertaking four A levels at Crossways Academy in Maths, ICT, and Physics and English. I enjoy the Maths the most. Since being in the UK I have volunteered with a number of different organisations, and made a documentary about my crazy life which helped me to increase my self confidence. I love sports including volley ball, football and netball. I also like being with my friends. I have overcome many hardships and obstacles through determination and perseverance. I want to studying civil engineering at university.

Marysa Dowling
is a photographic artist living and working in London. Her practice is concerned with human behaviour. She works closely with her subjects to explore the ways in which people represent themselves, and looks at how we function within society.
She has exhibited at the John Kobal Portraiture Award in the National Portrait Gallery, The Whitechapel, and at The Photographers' Gallery. She has also worked widely as an artist educator including at The Whitechapel, the National Portrait Gallery and the Chisenhale Gallery. She is currently working on a commission of new work with LACMA in Los Angeles.

Qasim
I am from Afghanistan. I like bike-riding, rollerblading, football and photography.

Anthony Lam
is an artist whose diverse practice is located within representational and social concerns, addressing issues of identity, culture and place from a personal and social political viewpoint. He has shown both nationally and internationally and led on collaborative projects with UK institutions including The Photographers' Gallery, Barbican Centre, Chisenhale Gallery, Chinese Arts Centre, Hayward Gallery, Museum of Childhood, Museum of London, National Portrait Gallery, The National Trust and the V & A. His previous projects include 'Notes from the Street' and 'Port of Call.'

Chen Feng Chen
In my photography I want to capture a moment before it is gone. I do not decide what I will photograph, I just see a moment and try and record it.
I am 18 years old. I was born in Nanking, China, and came to London in November 2005. I am studying ESOL entry level 3 at Leyton 6th Form College. I like photography because you can find that some things surprise you after you have taken the photograph. And everything you have photographed will one day become history.

Gayle Chong Kwan
is a London-based artist, working with photography, video, sound, installation, and performance. Her work is often context-specific or involves people in rituals of exchange, such as food or trade, to explore ideas of history, the senses and memory.
Gayle has shown extensively in the UK and abroad, including: PhotoEspana; Museu Colecção Berardo, Portugal; British Residency, Paris; Platform for Art, London; the National Portrait Gallery, London; Tate Britain, London.

PHOTOGRAPHERS / MENTORS

Sharafat Marjani
I am myself, I am un-like any other person. I am from Afghanistan but I now live in the UK. Nice people, nice country, I am safe here. But it is not easy for me, things in this country are so hard. I want to build a life for myself here. Nothing big, but something solid.

Anna Kari
is an award-winning Danish/Norwegian photojournalist whose work concentrates on people, human rights, minorities, and refugees, with a focus on Africa and eastern Europe.
Anna's work has been exhibited widely including the European and UK Parliaments, Glasgow Gallery of Modern Art, The Courtauld Institute of Art, Proud Gallery and the Imperial War Museum. Anna won The Observer Hodge Award for Digital Photographer of the Year in 2005. She co-founded the photographic collective, Documentography.

Tatiana Correia
I am 23 years old and came to the UK from Angola in 2001. I am now a British citizen and studying for a Photography degree at the London College of Communication. Identity is my main interest alongside modern sociology and all that goes with it. Doing that kind of course, in an environment where people are not familiar with refugees and their needs, has been very hard. It is funny how with just a little help, you can be at the 'same' level as others and as a consequence you can MAKE IT. Photography is now my therapy to cope with daily life.

Jillian Edelstein
has taken portraits that have appeared widely in the international press, including the New York Times Magazine, The New Yorker, Vanity Fair, Interview, The Sunday Times and Time Magazine. She is represented by the Richard Morehouse Gallery in the US. Jillian has received several awards including the Kodak UK Young Photographer of the Year, and the Visa d'Or at the International Festival of Photojournalism for her work on the Truth and Reconciliation Commission. Her book 'Truth and Lies' won The John Kobal Book Award in 2003. She has just completed her second book, 'Sangoma.'

Dorky, Berny and Flowers

We are sisters. We came to England in January 2007. We are Congolese. We speak four languages: Lingala, Tshiluba, English and French. We all have different talents, ambitions and hobbies. Between us we can sing, dance and act.

Ilona Suschitzky

is a contemporary fine artist, who was born and raised in South Africa. After emigrating to England. she continued painting, and worked as a research assistant to Sir Lawrence Gowing. In addition to exhibiting and carrying out many commissions, including portraits, book illustrations and record album covers, Ilona also undertook murals for public and private spaces. She has also collaborated extensively with the artist and photographer Sarah Moon. In Autumn 2008, a collection of children's stories by Betty Misheiker and illustrated by Ilona Suschitzky will be published in France.

Sarah Moon

lives and works in Paris. Her career spans over 30 years and includes commercial fashion photography for some of the world's top designers, a huge body of distinctively styled personal work, and a series of films. She has received various awards including the Grand National Prize for Photography in 1995, and most recently the Grand Prize from the German Photography Society in 2008. She has exhibited all over the world including Paris, Milan, New York, Kyoto and Moscow. She has published and produced numerous books and films. Her next book, 'Sarah Moon 1 2 3 4 5' will be accompanied by exhibitions at the Royal College of Art and Michael Hoppen Gallery.

PHOTOVOICE

DOST : DEVELOPING POSITIVE MINDS

PhotoVoice is an award-winning international charity whose **mission is to bring about positive social change for marginalised communities by providing them with photographic training with which they can advocate, express themselves and generate income.** Its projects empower some of the most disadvantaged groups in the world with photographic skills, and so help them transform their lives. Through in-field photography workshops, PhotoVoice assists those who are traditionally the subjects of photography to become its creators. Using specialist methodologies, PhotoVoice projects help support individuals and groups to develop a voice, and enable them to speak out about their challenges, concerns, hopes and fears. Internationally, PhotoVoice provides the platform for these groups to exhibit and market their work and to inspire change. PhotoVoice projects span four continents working on key themes including HIV/AIDS, refugees and disability. Where possible, they also provide long-term support for individuals to pursue careers in their local photographic and media industries. PhotoVoice believes in the right of all individuals to be able to access the tools and skills through which they can find strength in their own voice and the means to represent themselves. It is committed to enabling marginalised groups to influence the decisions that affect their lives through self-representation in order that sustainable change can be achieved.

Dost (meaning friend) grew out of our struggle to help Mirwais, from Afghanistan, to get into school. That was eight years ago, Mirwais is now at university studying medicine. Like Mirwais, most young refugees we work with are fleeing violent conflict; many have survived traumatic experiences in their countries of origin and during the dangerous journey to safety. Often, they are distressed and fearful, having lost their homes, families, friends and all that is familiar. By providing intensive and long term support we help them to re-build their lives and become part of a community.

We are based at Trinity Centre, a registered charity in East London, a thriving centre used by 15,000 people each month. Our community base is integral to our work, it offers a safe space where people of all ages come together to share in each other's lives. Within this context, we support vulnerable children aged five to nineteen, in particular, young separated refugees. Through education, play, advice, advocacy and therapeutic support we help children develop positive minds.

Our full-time education programme enables children to learn English and skills to live independently. We advocate on their behalf to get them into school or college as soon as possible; many continue to further and higher education. We facilitate 1500 hours of play a year through clubs, playschemes, creative projects, sports, day trips and residentials. Our activities are designed to tackle isolation, promote cognitive and emotional development and support children's self-esteem and confidence. We provide advice and advocacy relating to education, the asylum process and Mental Health and Social Services support to help young refugees cope with the uncertainty of their present and future. At the heart of our work are the relationships we build with young people. We bear witness to their struggles and celebrate their successes.

www.photovoice.org

SPECIAL THANKS

The mentors:
Adam Broomberg and Oliver Chanarin
Gayle Chong Kwan
Suki Dhanda
Marysa Dowling
Jillian Edelstein
Liane Harris
Crispin Hughes
Anna Kari
Anthony Lam
Jenny Matthews
Sarah Moon
Jo Metson Scott
Othello De'Souza-Hartley
Ilona Suschitzky

Others:
George Alagiah, Paula Aspin, Camila Batmanghelidjh, Charlotte Cotton, Steven Davidson, Jon Hempstead, Laura Hirst, Hari Kunzru, Marc Schlossman and Elhum Shakerifar.

Additional thanks to New Londoners' funders:
Paul Hamlyn Foundation
City Parochial Foundation
Jack Petchey Foundation

The New Londoners project team includes :
Liz Orton and Tiffany Fairey from PhotoVoice; and Yesim Deveci, Trupti Magecha, Bali Hothi and Colin Ravden from Dost.

Published in Great Britain in 2008
By Trolley Ltd
www.trolleybooks.com

Photographs © Chalak Abdulrahman, Tatiana Correia, Chen Feng Chen, Qasim Gul, Mussie Haile, Ivano Kankonde, Al-Mousaoy, Sharafat Marjani, Shamin Nakalembe , Loria Siamia, Bajram Spahia, Lawrence Stopwar, Dorky, Berny and Flowers
Texts © Charlotte Cotton, George Alagiah, Hari Kunzru 2008
Creative Direction: Gigi Giannuzzi
Art Direction: Martin Bell and Wai Hung Young, www.fruitmachinedesign.com
Text Editing: Liz Orton, Hannah Watson

Printed in Italy 2008 by Grafiche Antiga